Art • Therapy

Disney

FROZEN

100 IMAGES TO INSPIRE
CREATIVITY AND RELAXATION

DISNEY
EDITIONS

For information address Disney Editions,
1101 Flower Street, Glendale, California 91201

Printed in China
FAC-032479

First United States English Edition, November 2015
1 3 5 7 9 10 8 6 4 2

ISBN 978-1-4847-5739-0

Winter settles gently in the night, for now the snow is queen…

Once upon a time in the kingdom of Arendelle, there was a princess with secret powers so strong that she was forced to live in solitude and sorrow. But one day these long-hidden powers were unleashed, and the entire country was frozen under an eternal covering of snow.

Now it's your turn. Rediscover the wonderful world of *Frozen* and bring life and color to the characters, scenes, and friezes of one of Disney's most beautiful films. A symphony of snowflakes, ice palaces, mandalas of stars, and winter vegetation sit alongside a joyful band of kind and wicked characters. Delve into a fairy-tale world with a backdrop of steep mountains, snowy hills, and trees that drip with icicles. Add your own warm touches to the rich décor and Nordic motifs: Scandinavian costumes and embroidery; objects from the frozen north.

Use your own colors to reinterpret the compelling love story of two sisters separated by fate, battling to overcome the many obstacles of this eventful fairy tale.

With simple crayons or colored pens you, too, can venture into this world and relive the enchantment of *Frozen*.

Relax and enjoy the pleasure of creation.

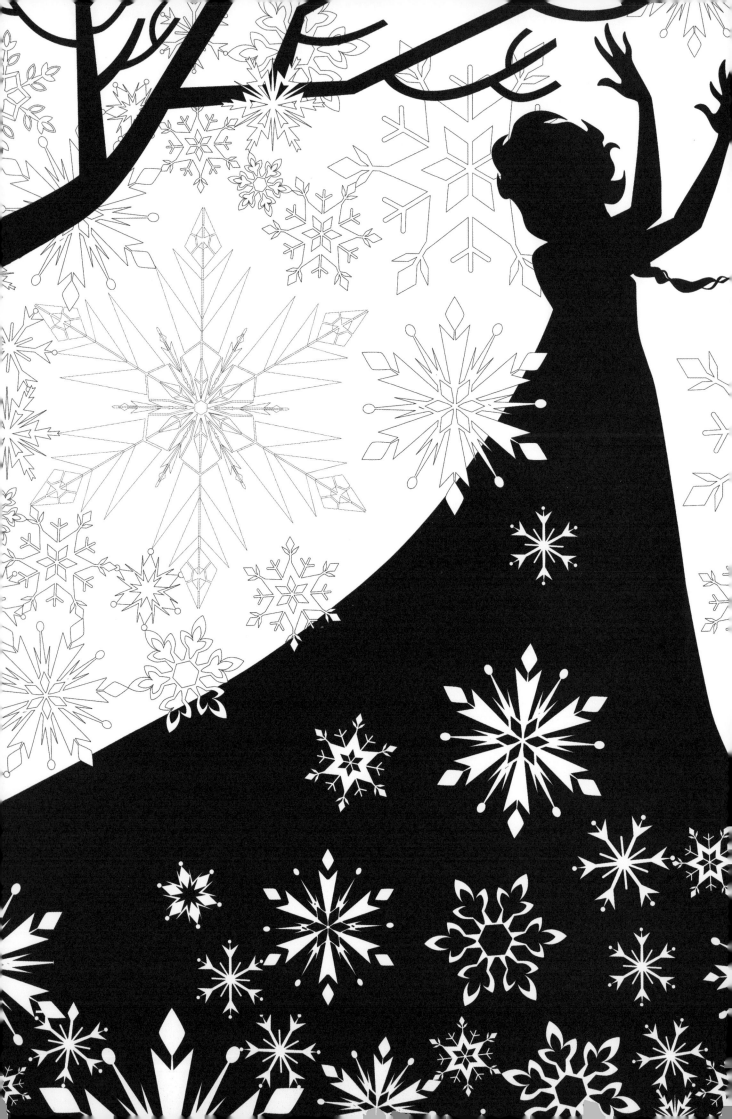

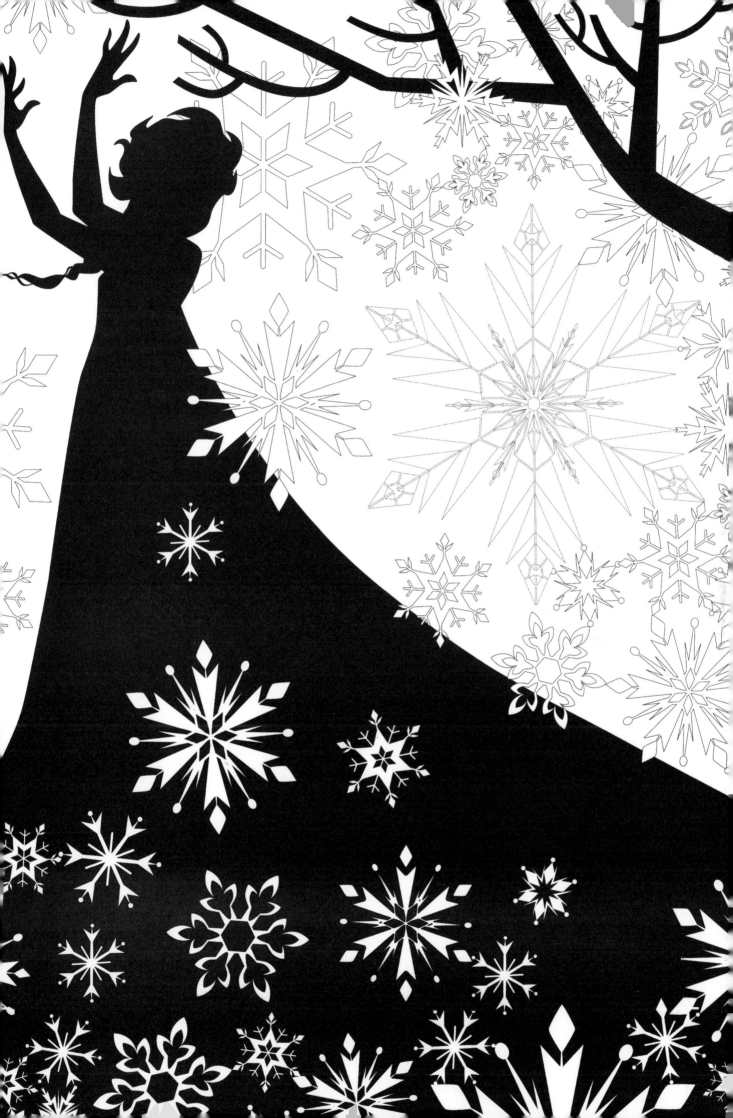

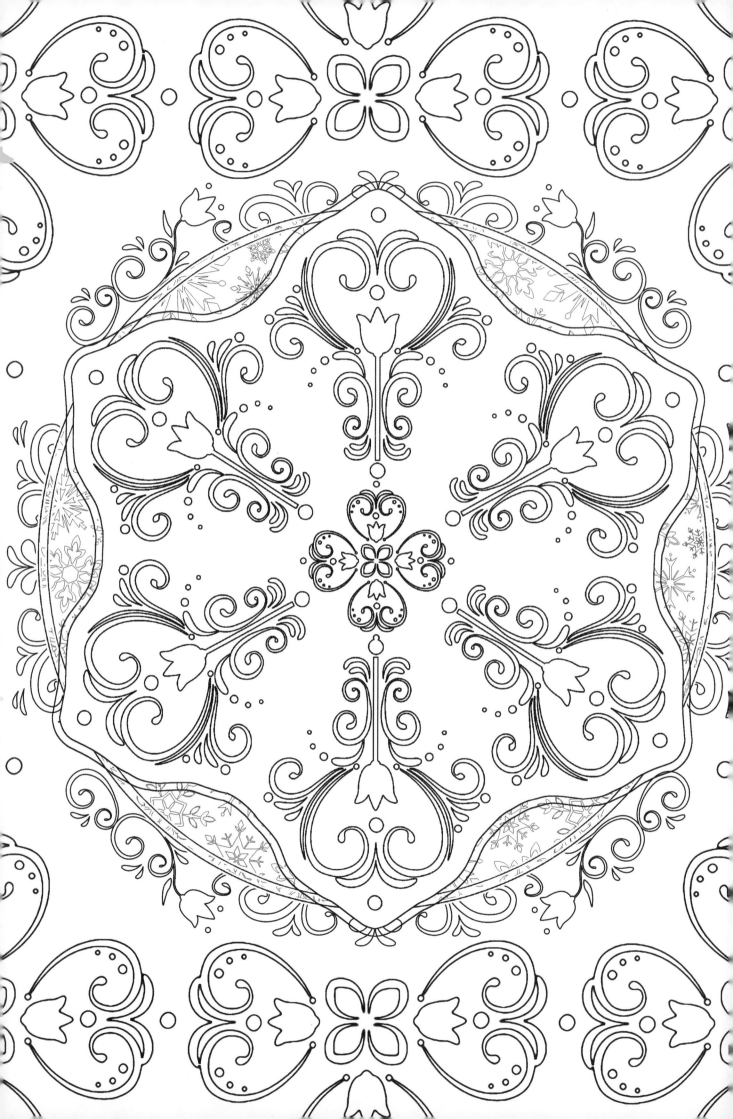

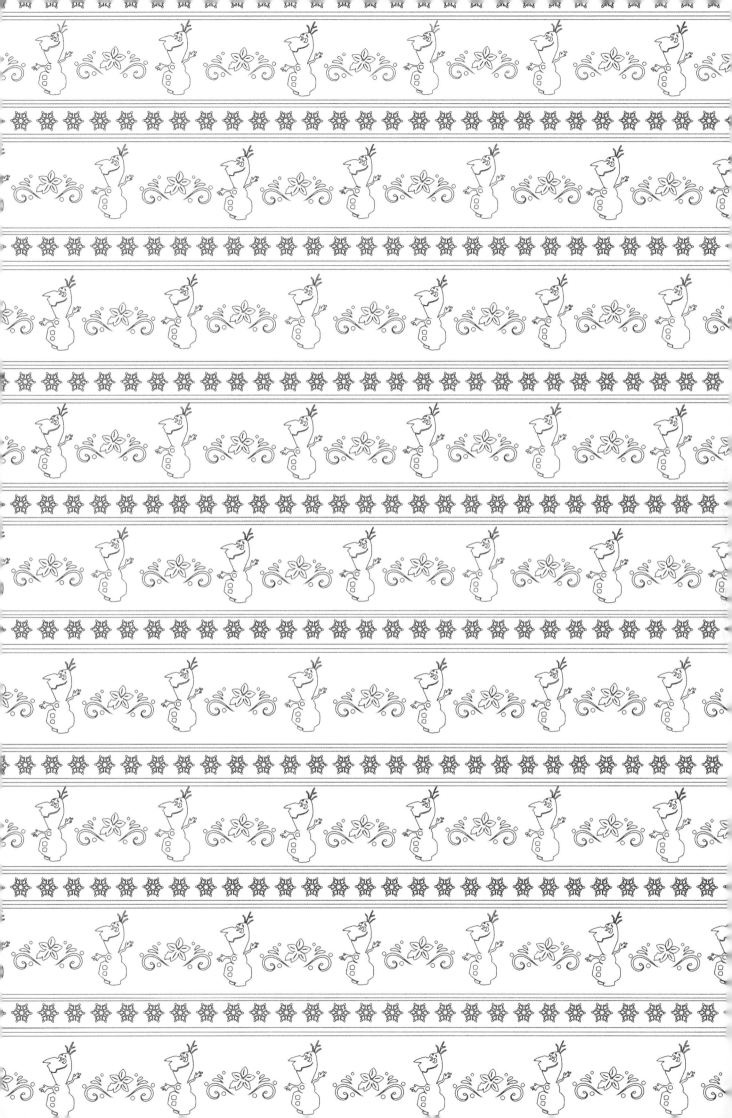

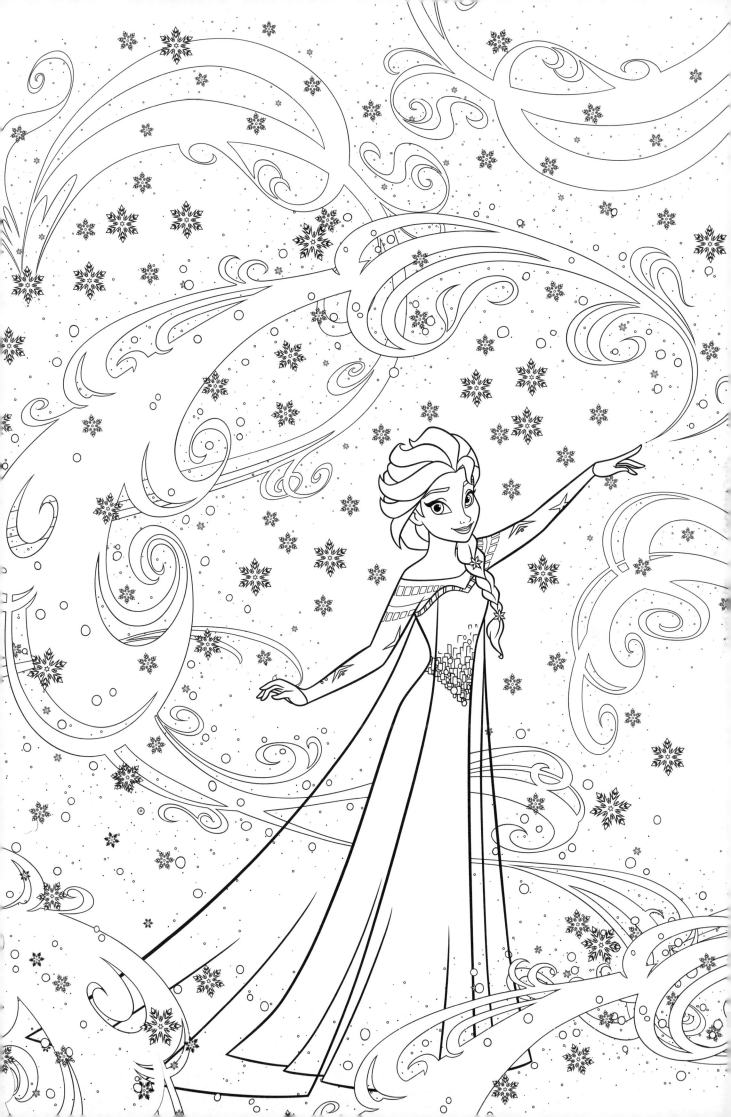

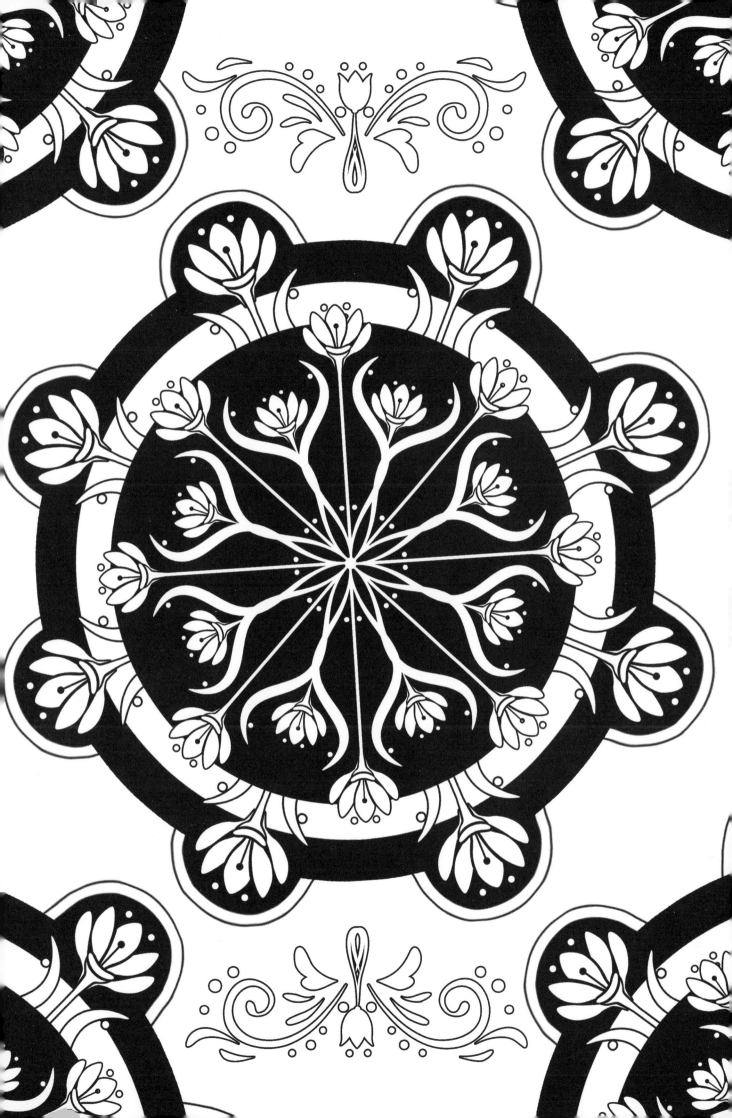

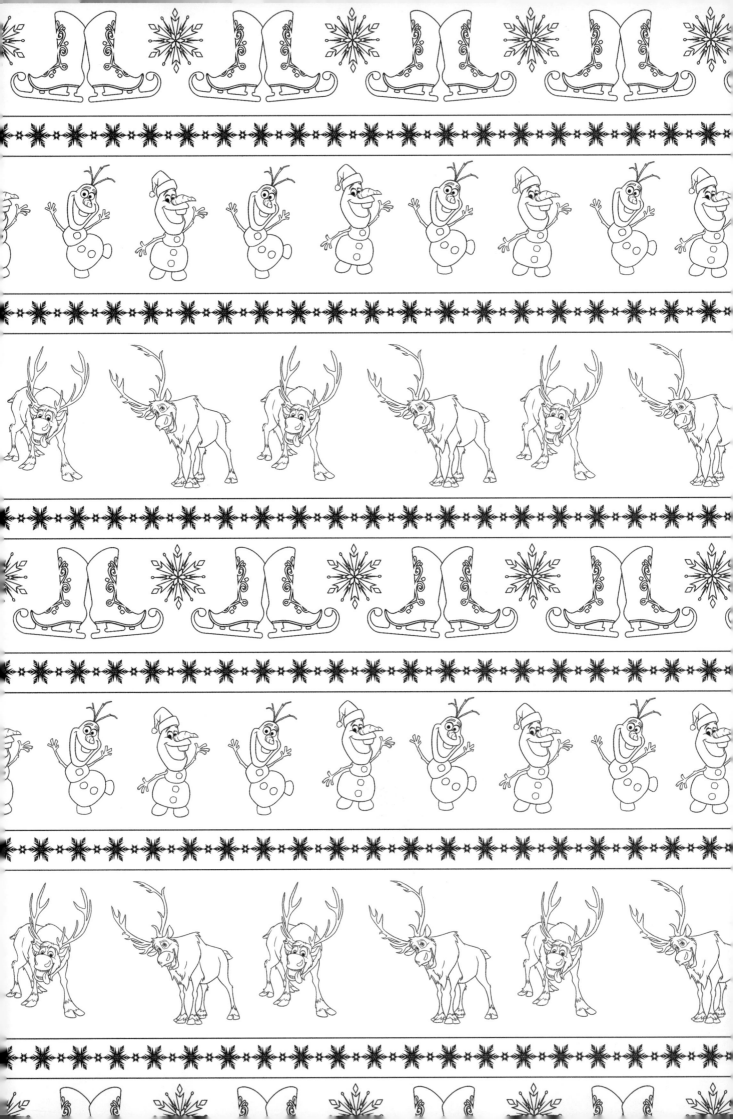

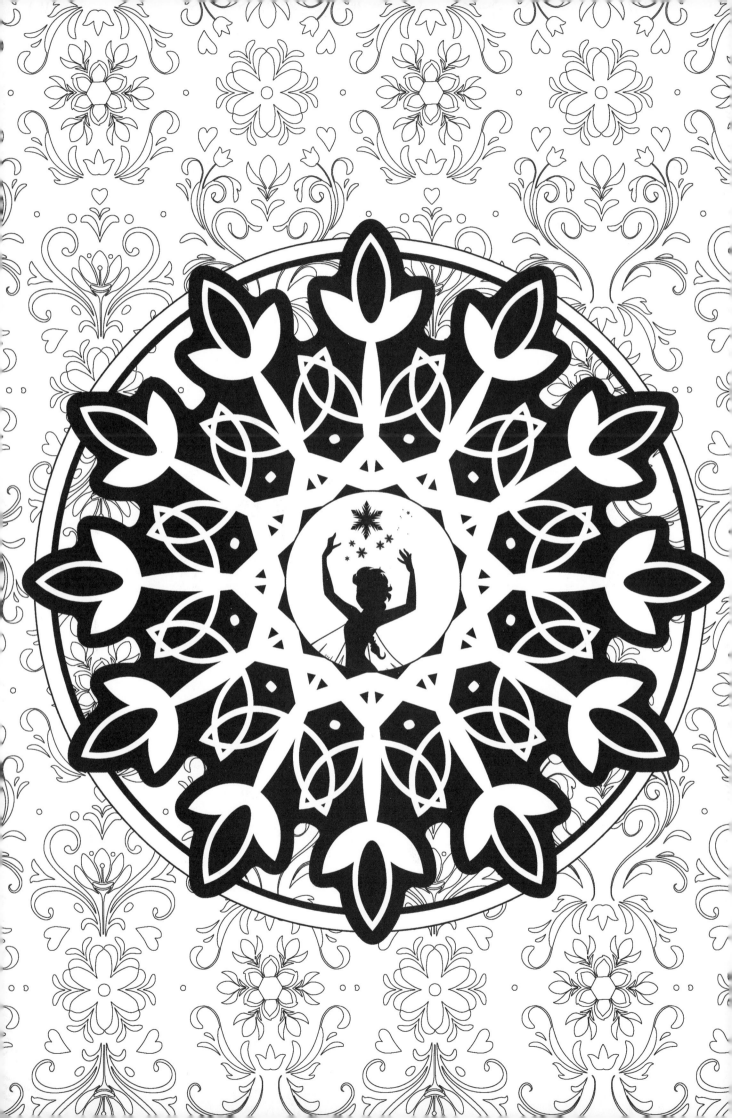

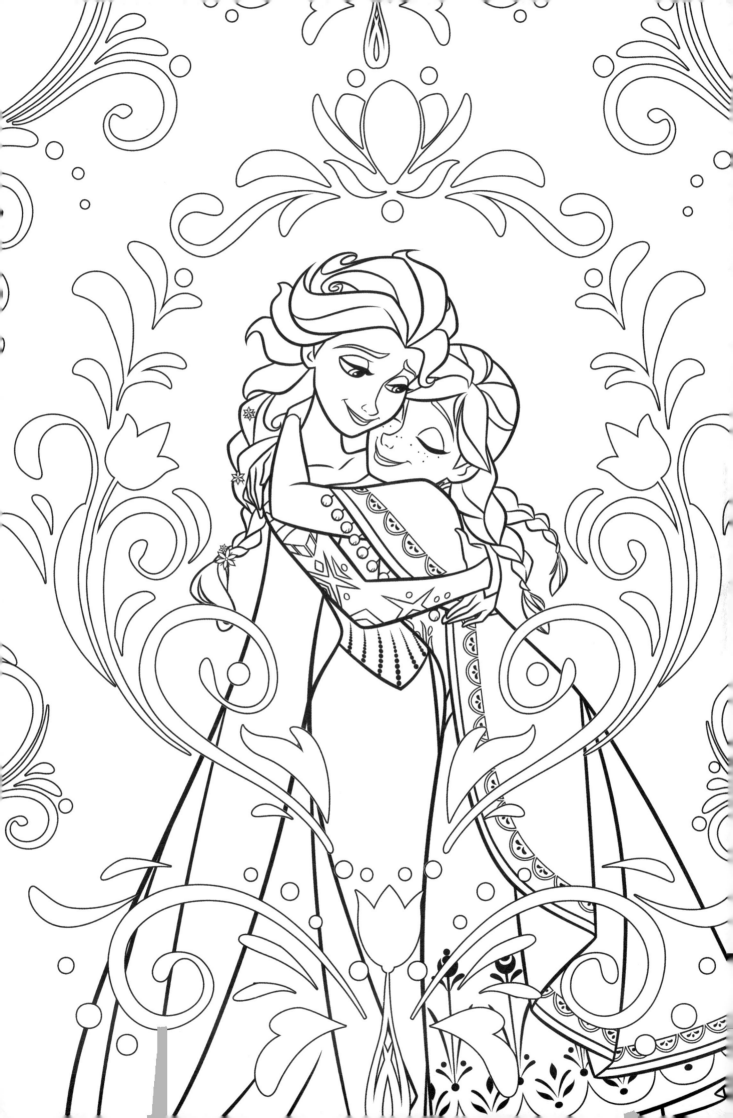

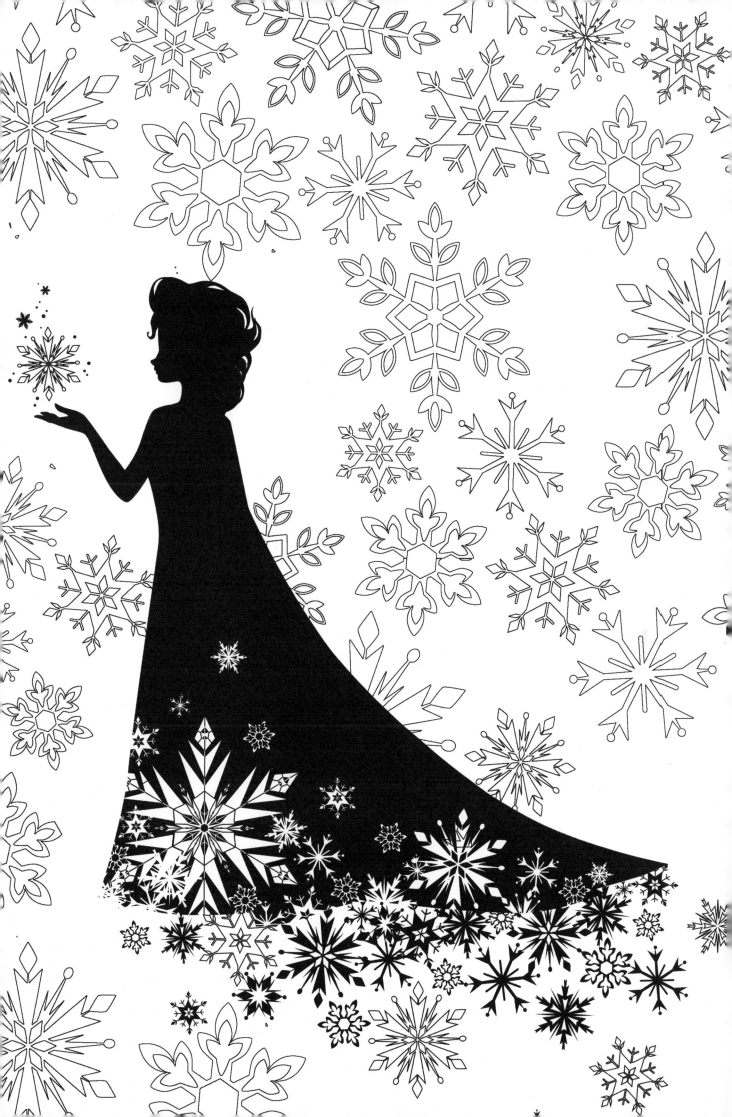

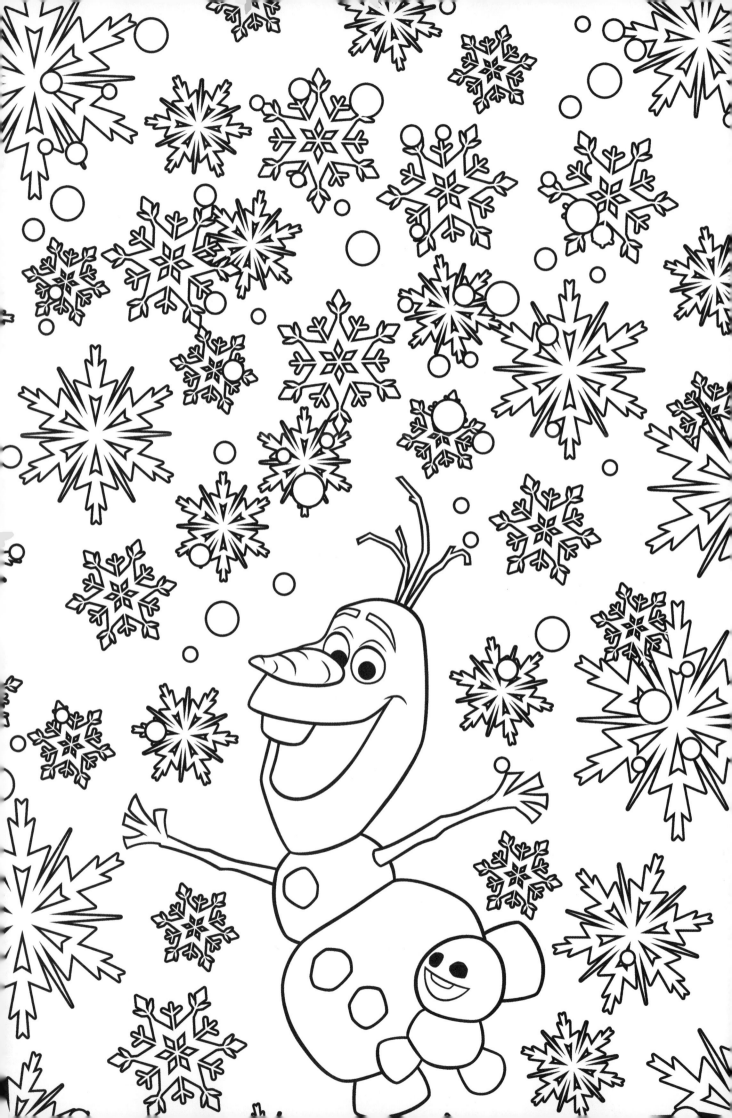

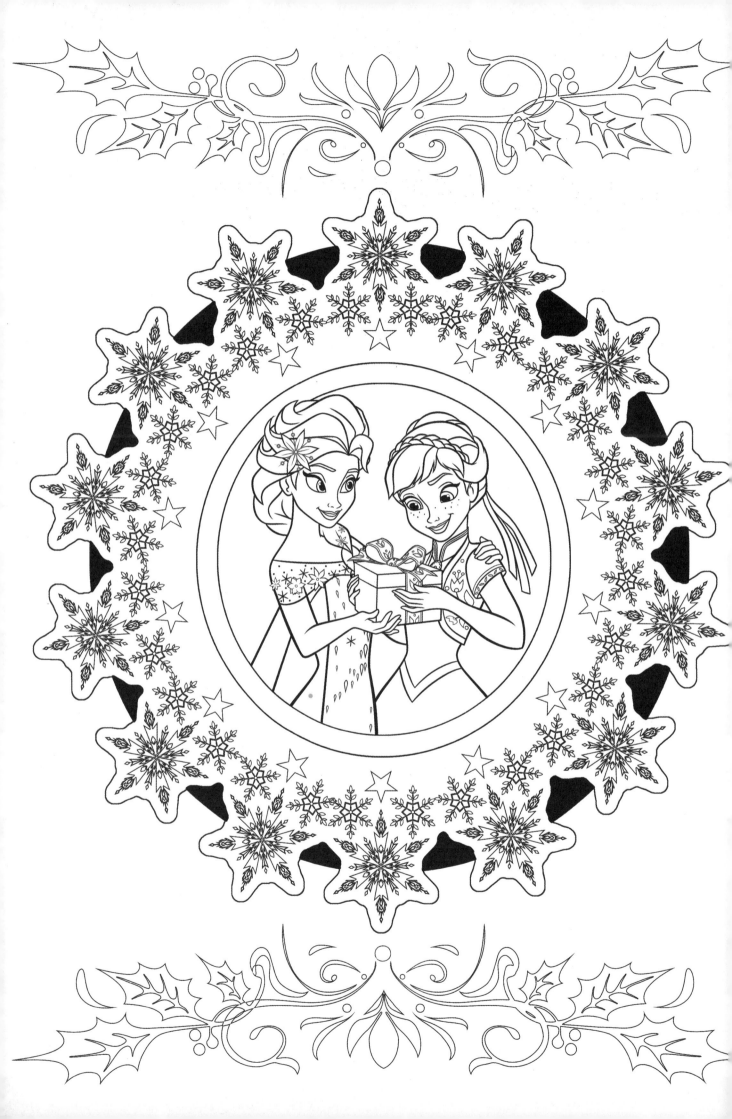

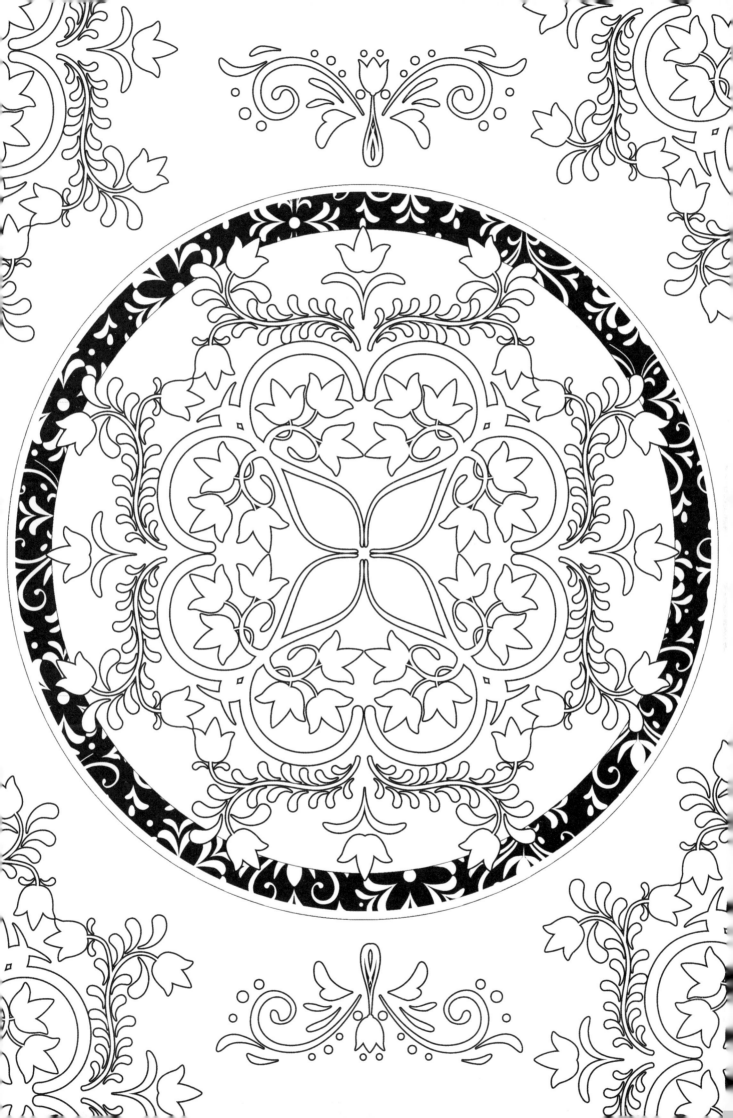

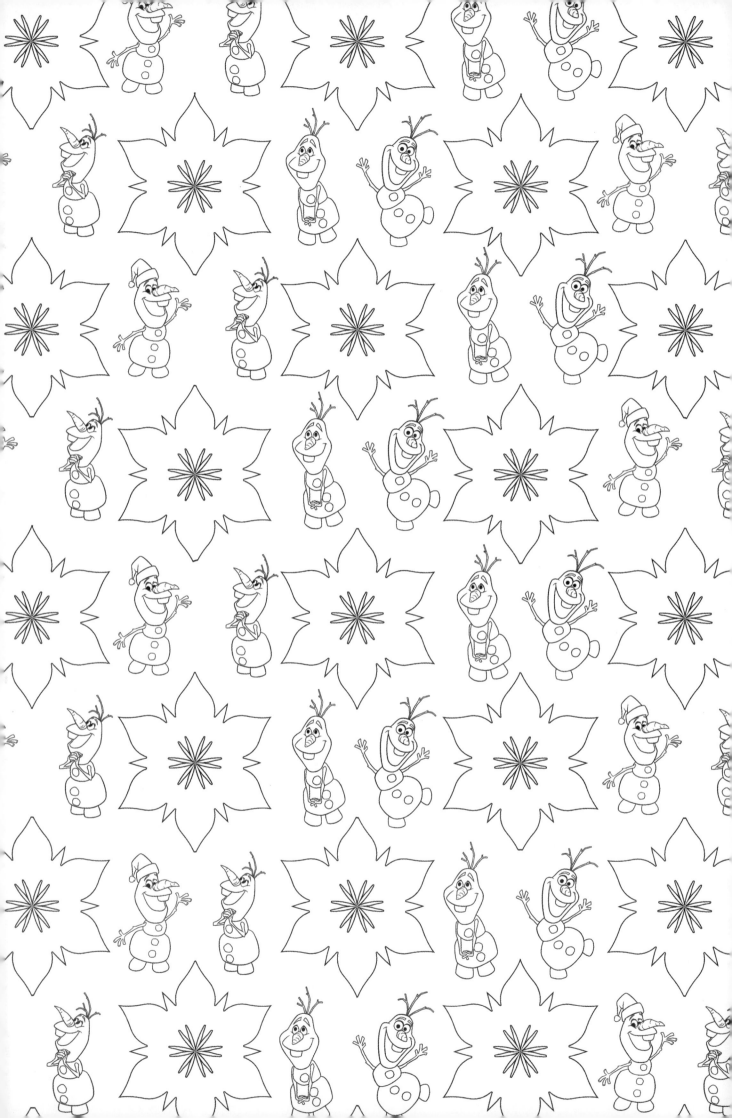

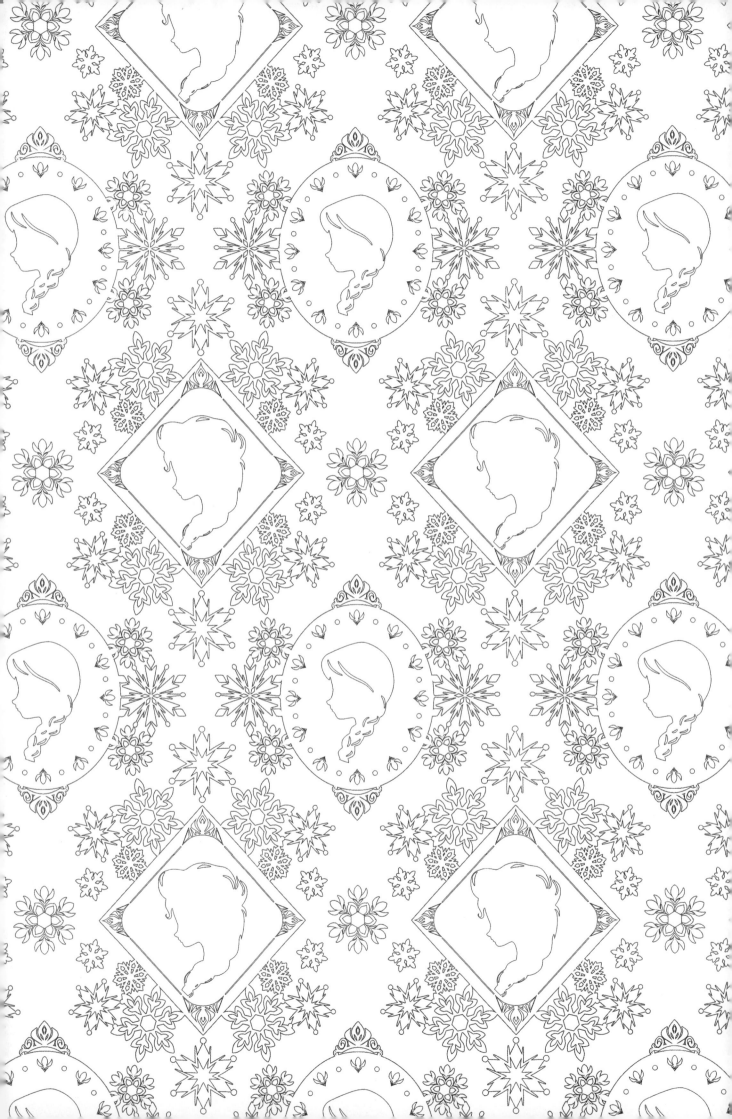

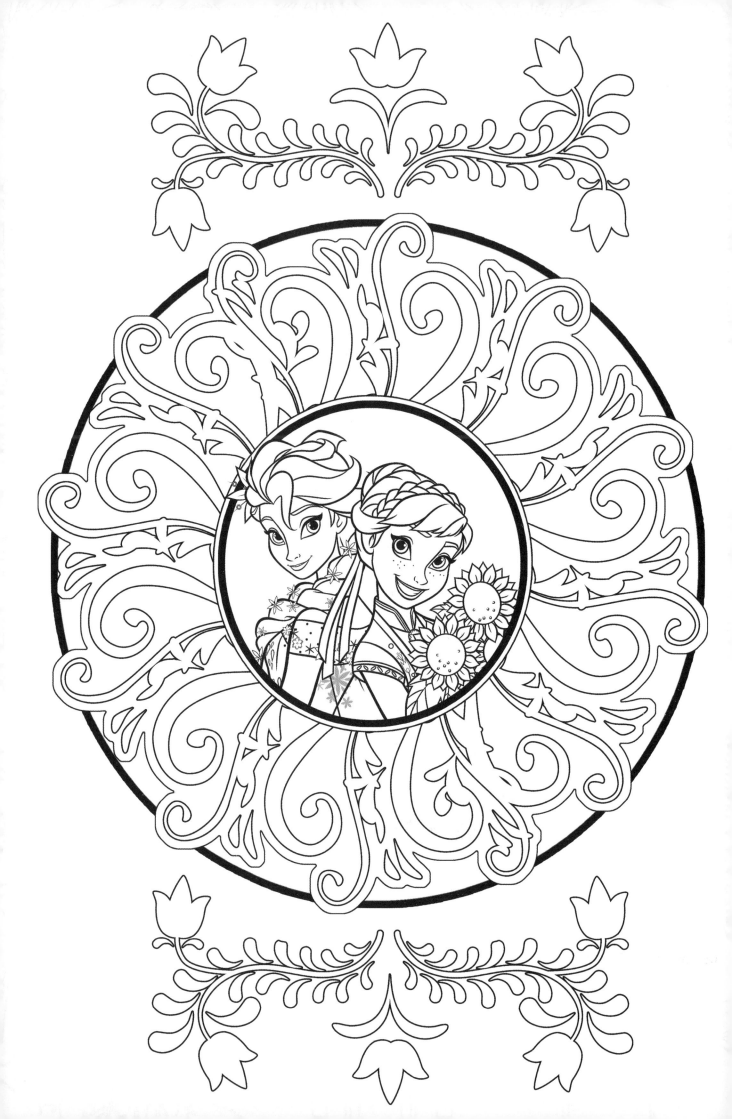

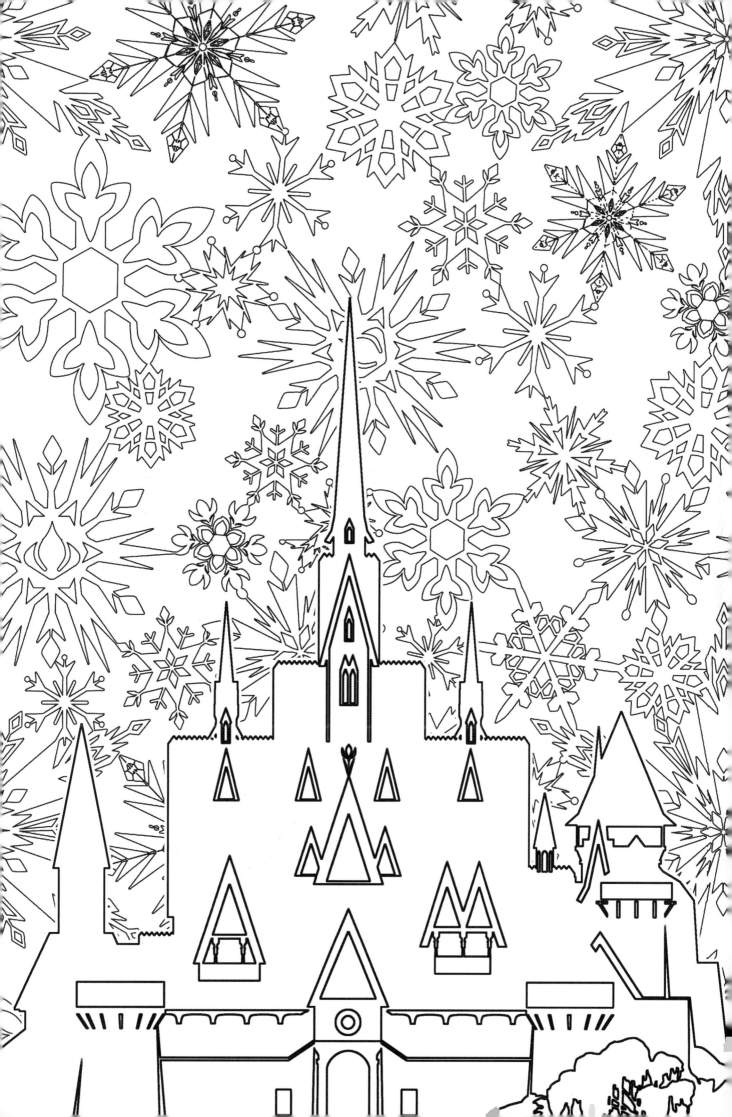

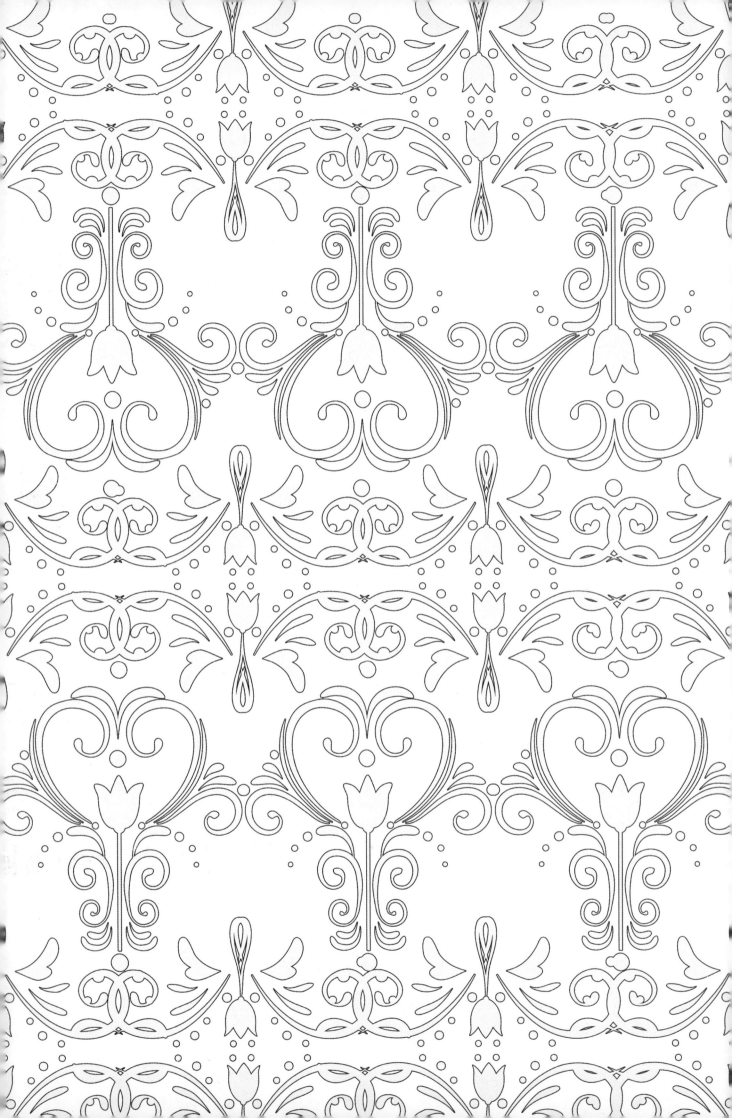

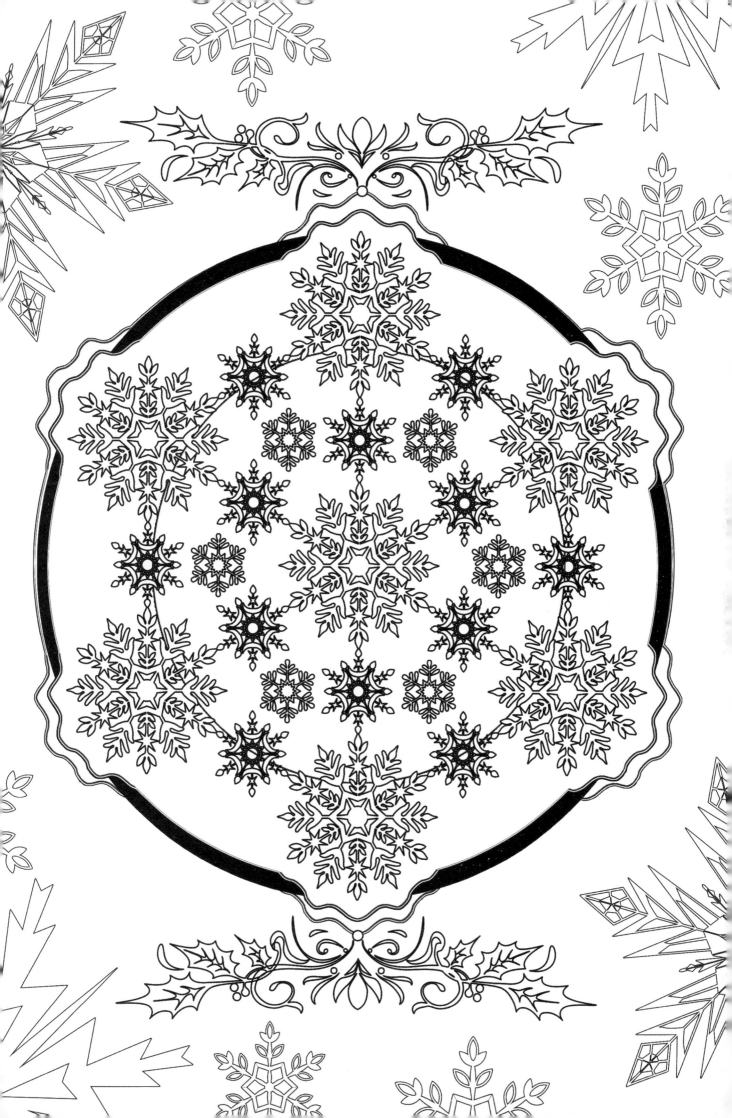

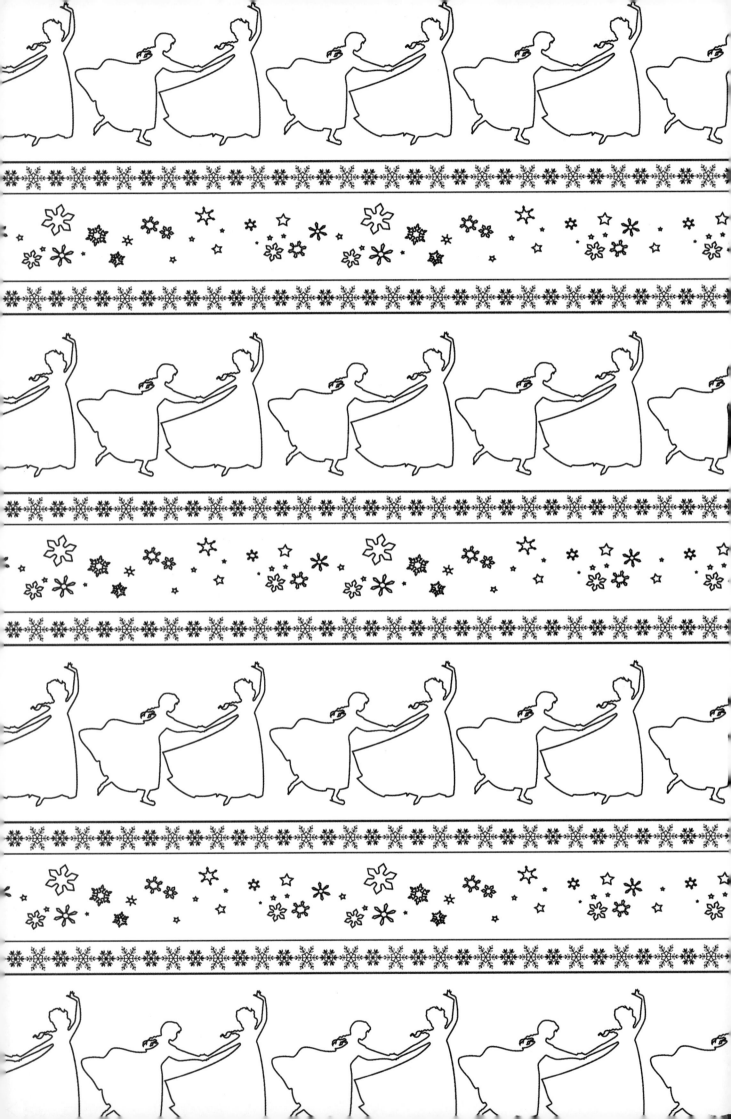

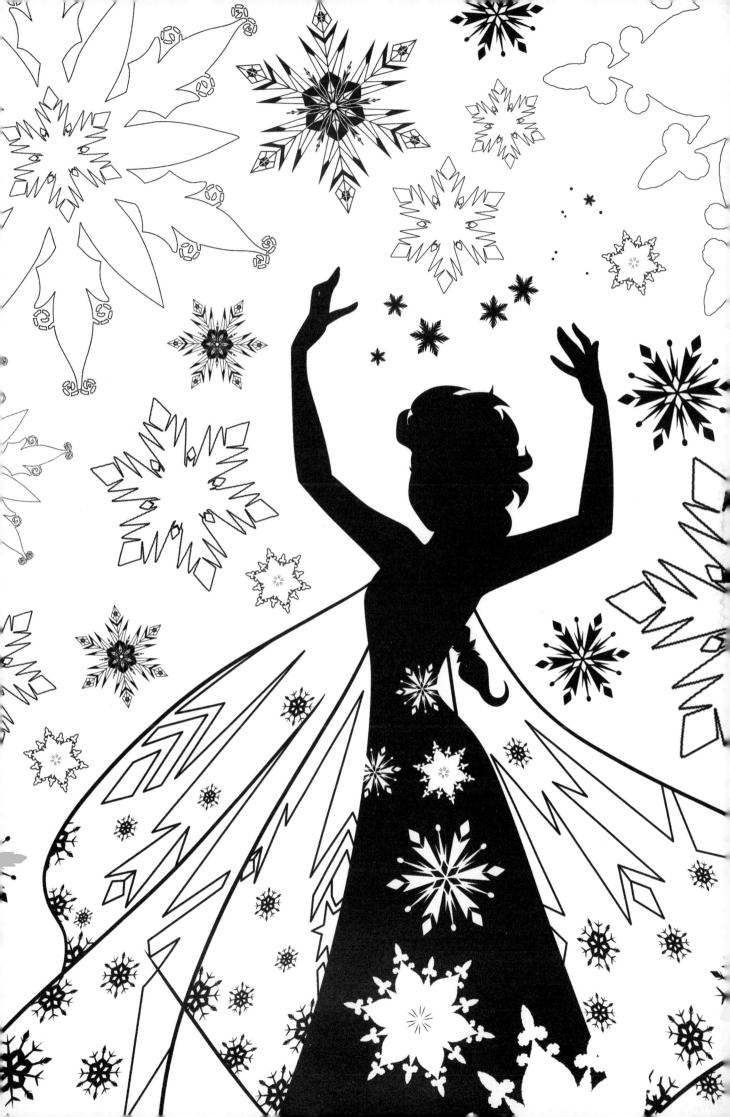

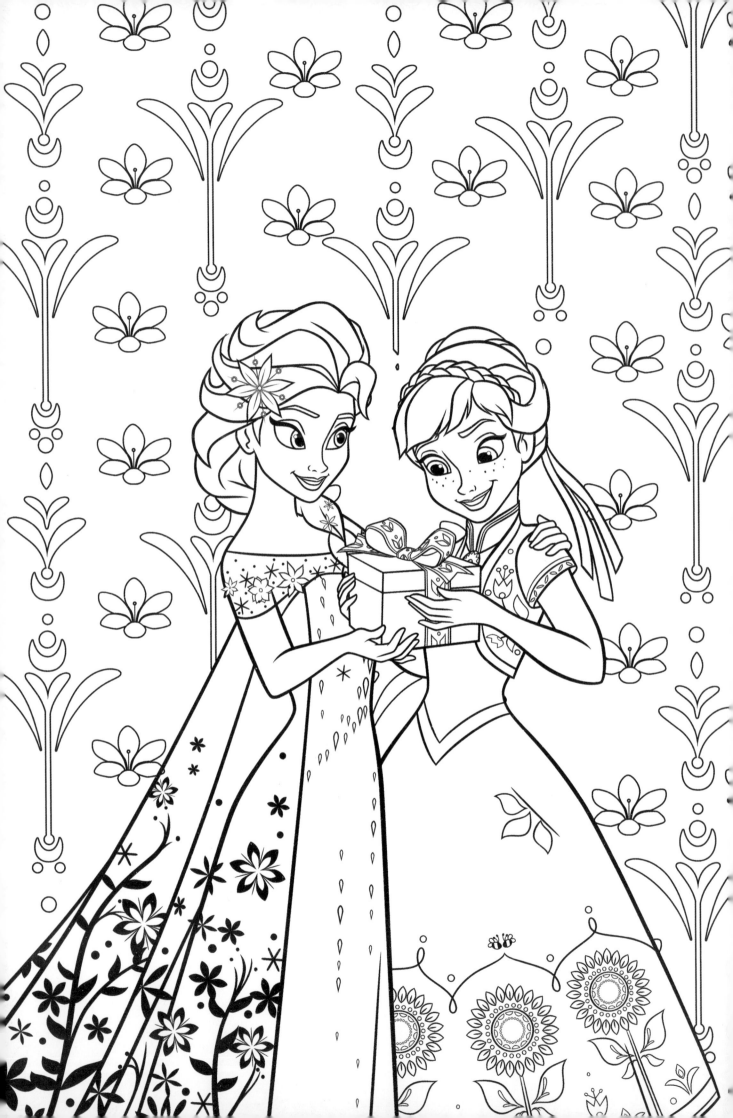

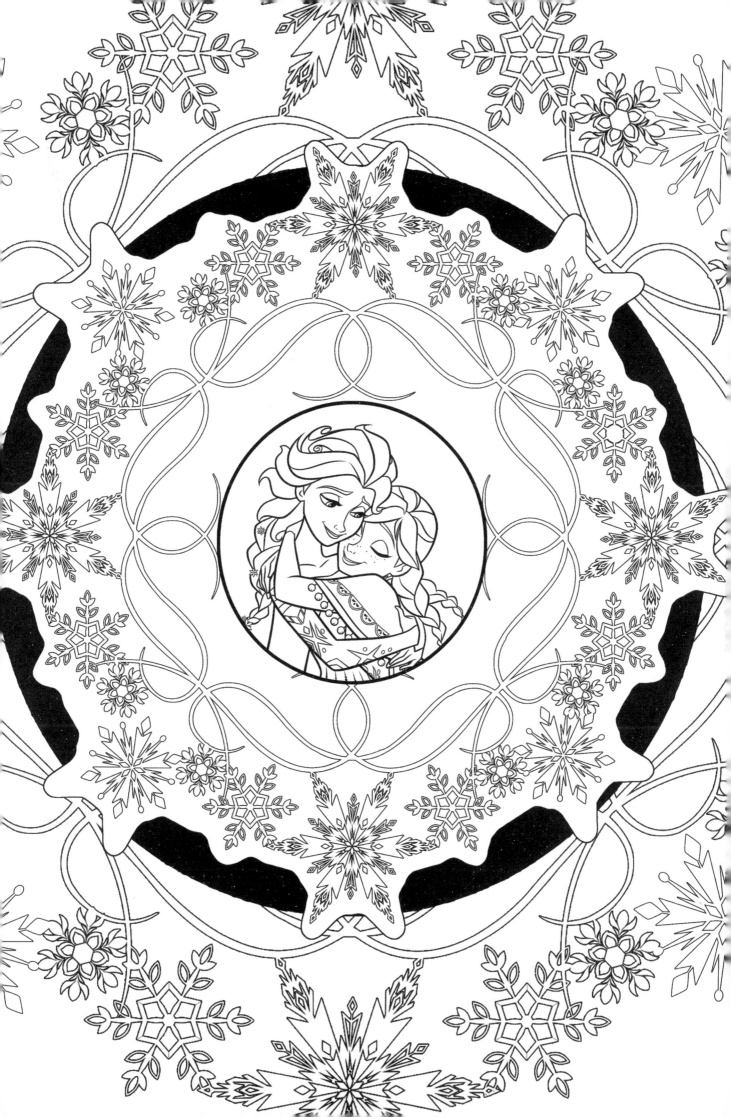

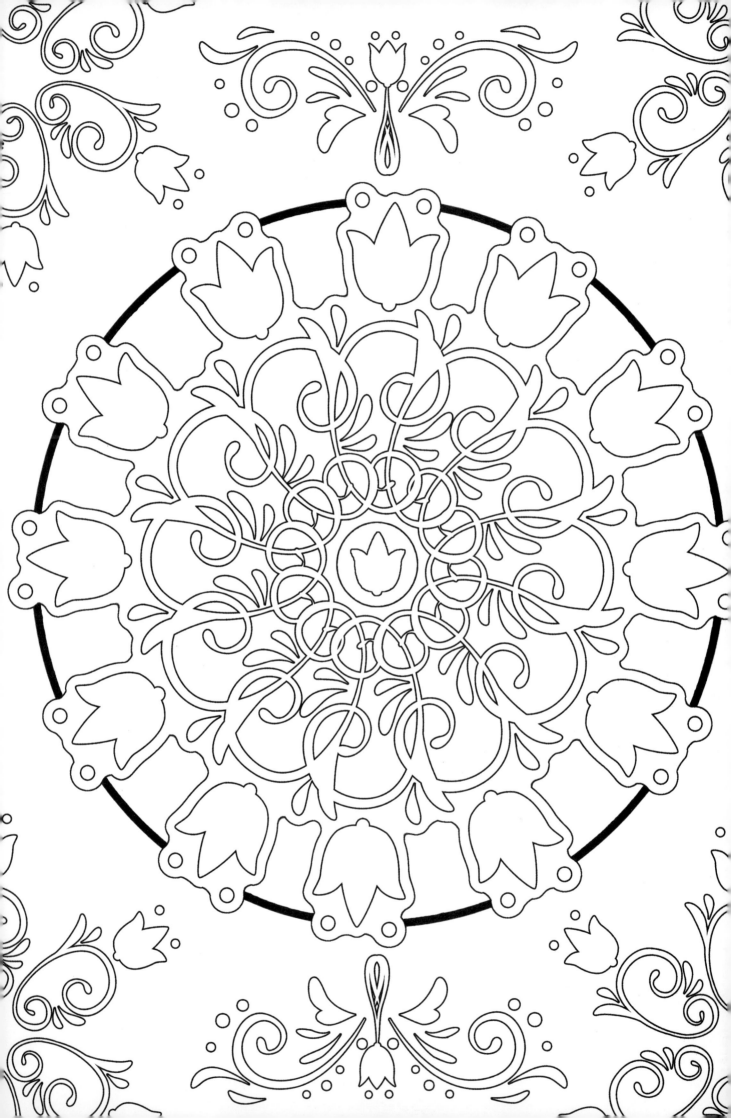

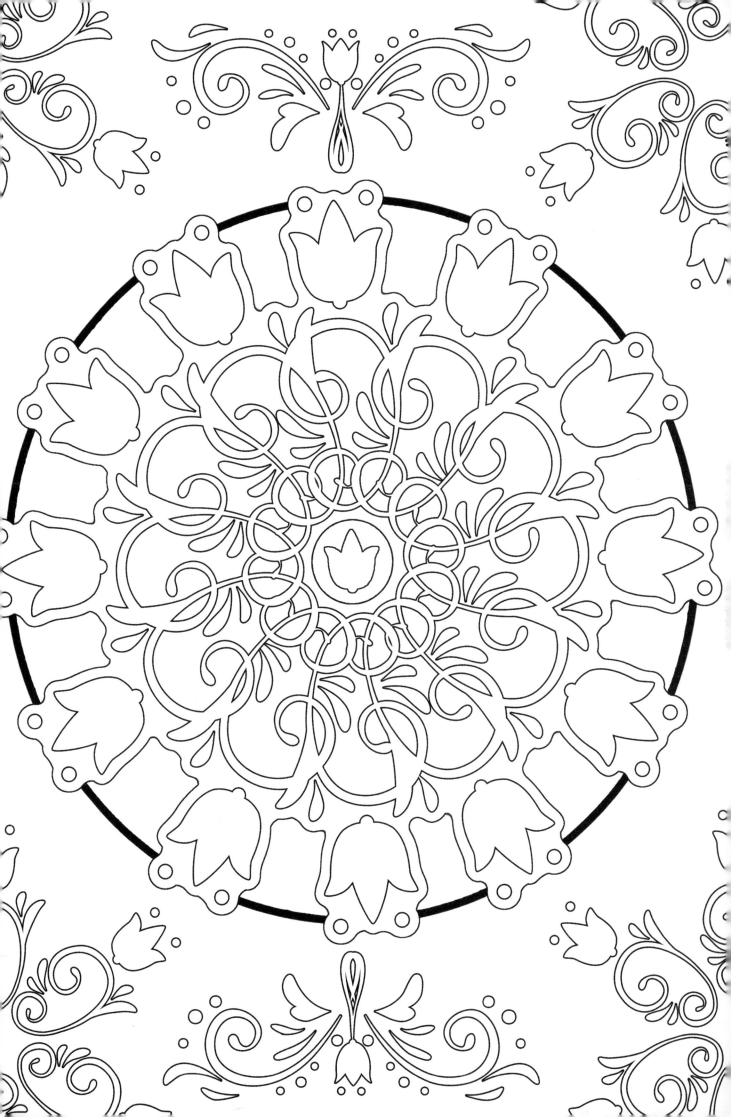

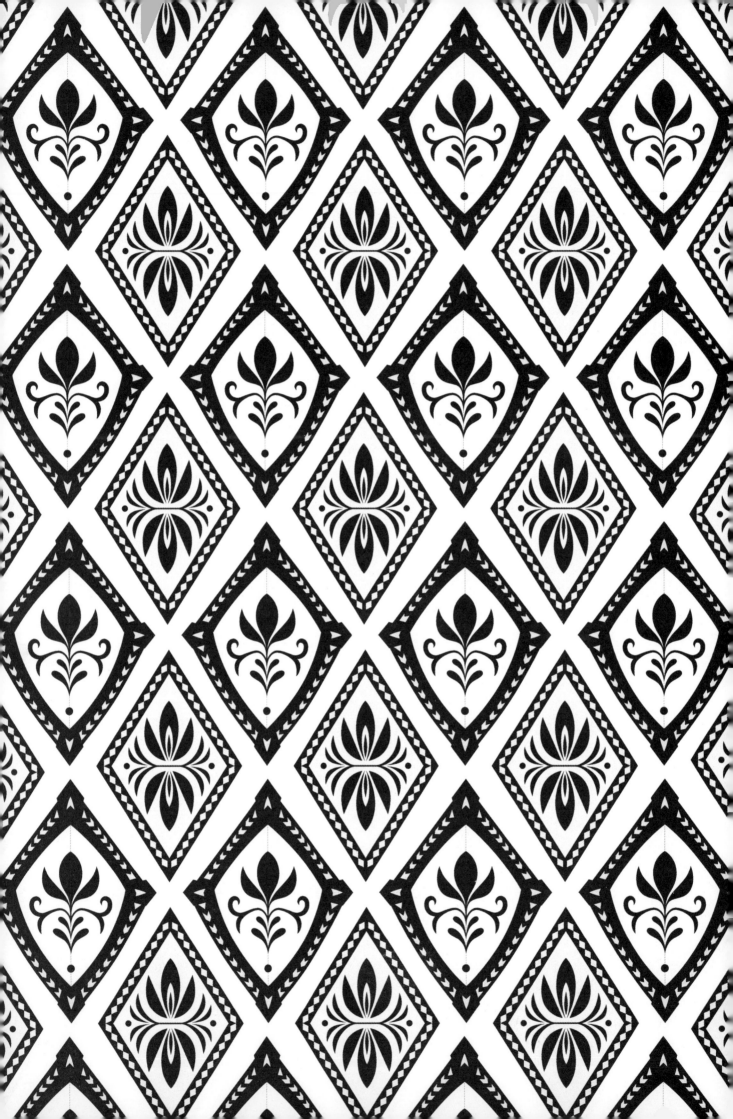

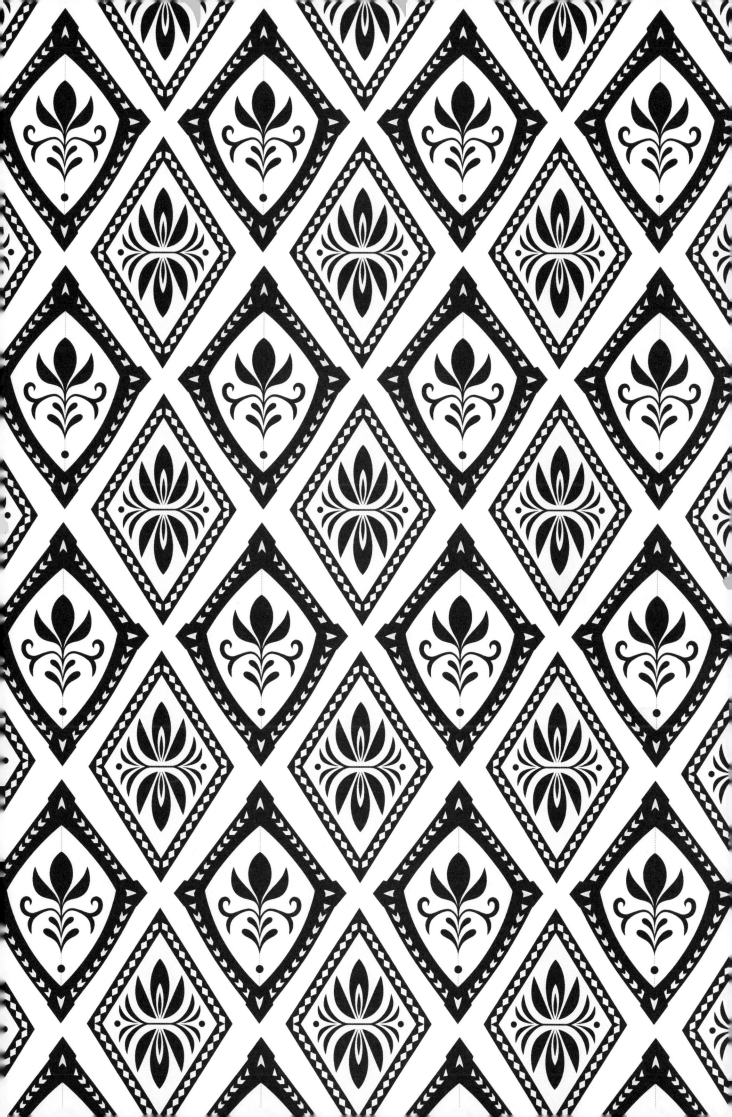

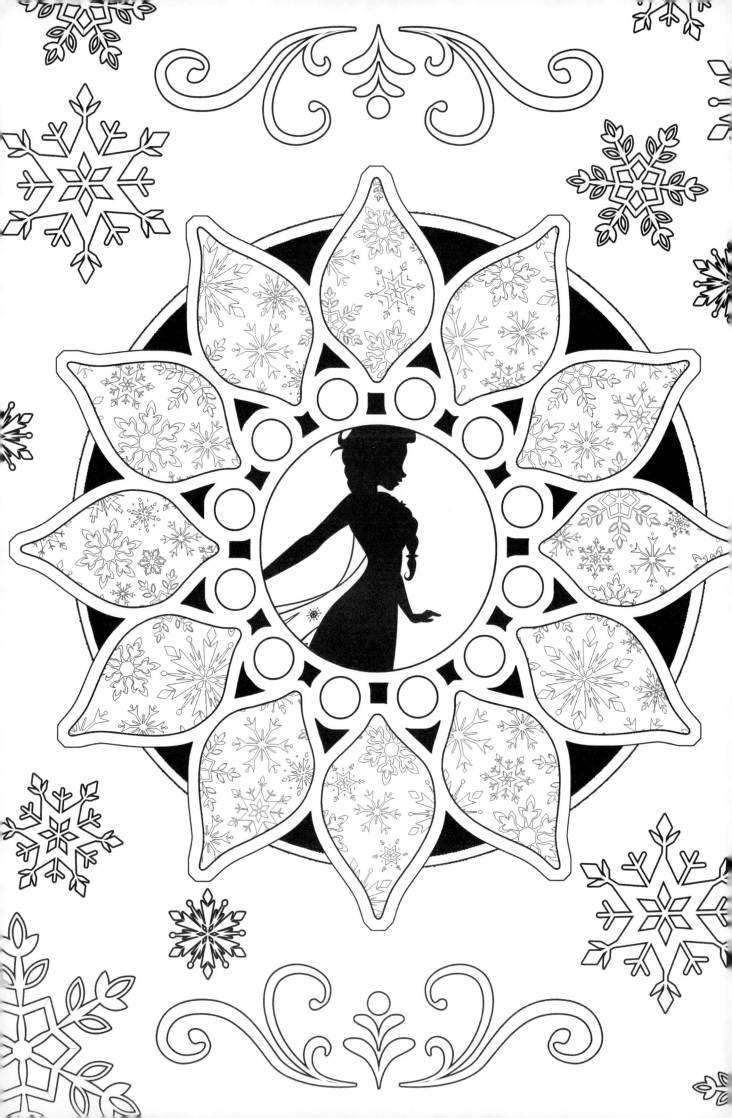

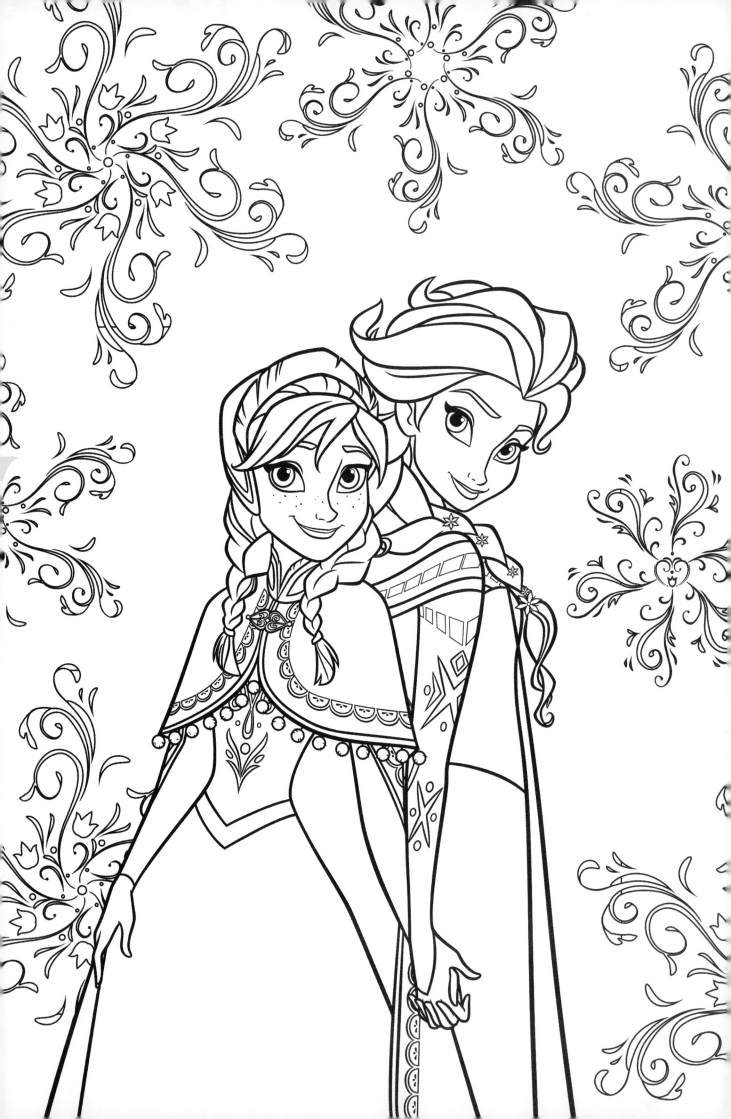

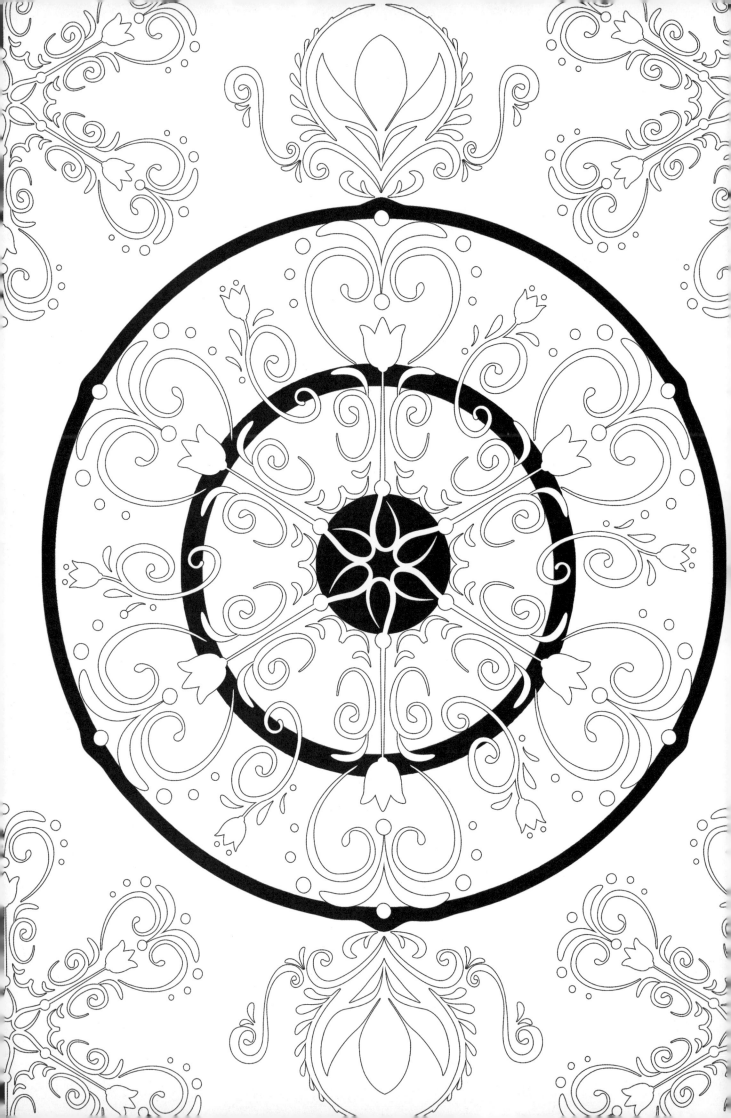

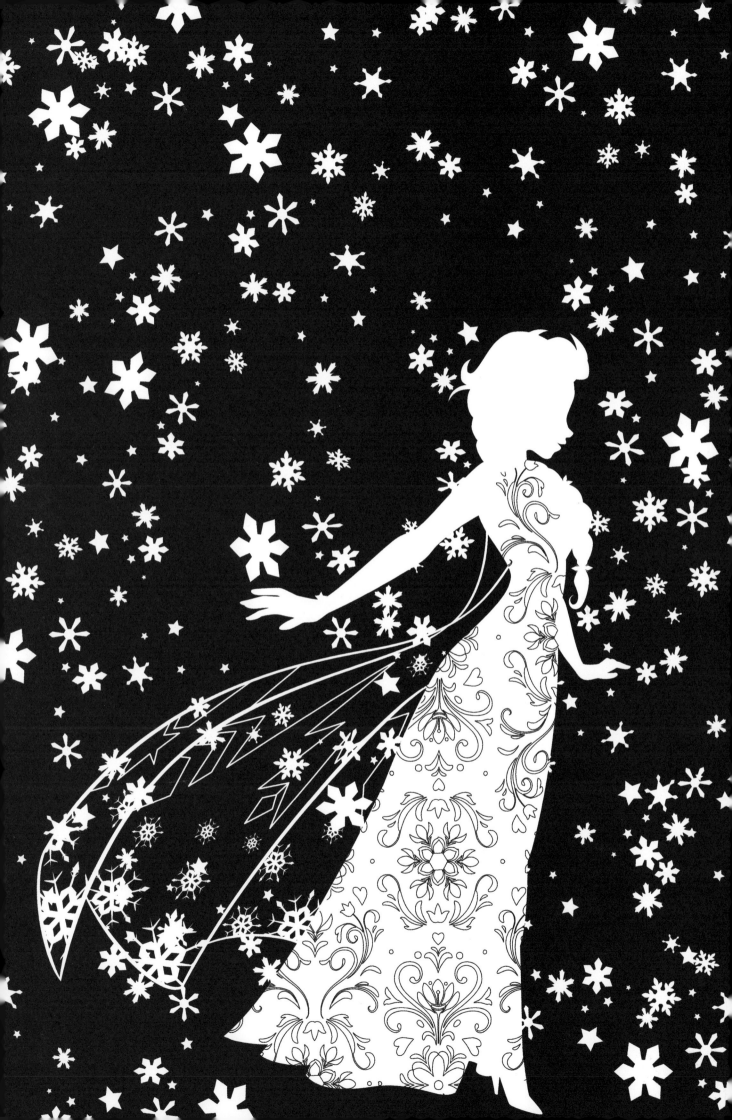

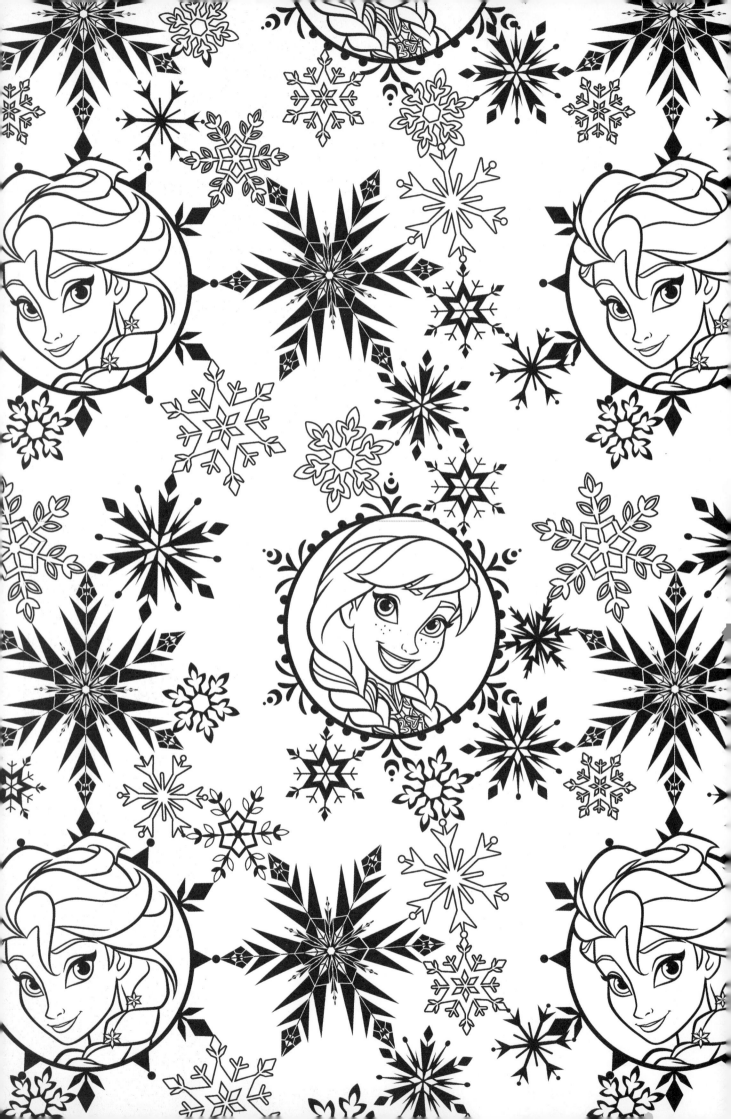

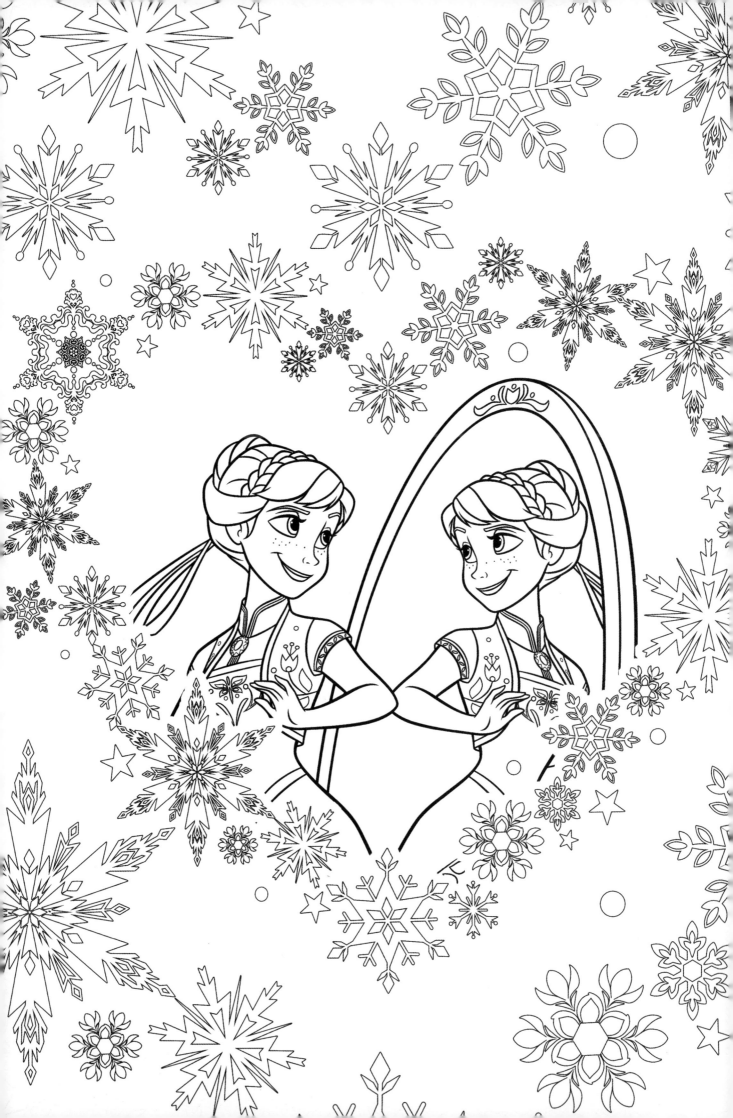

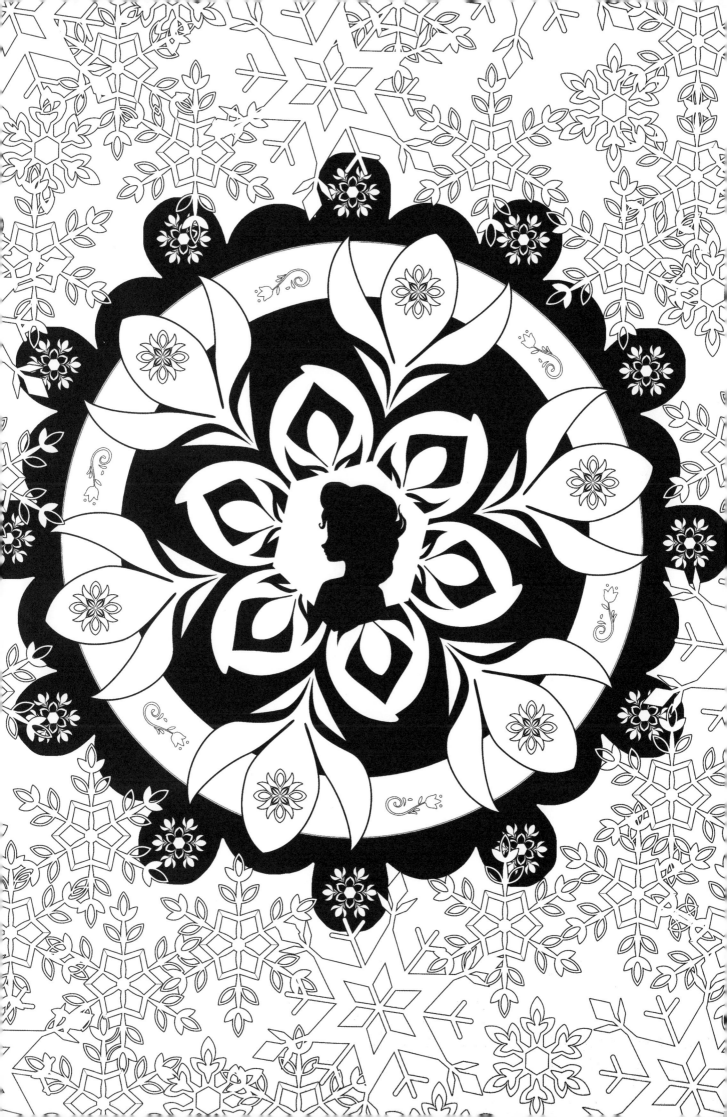

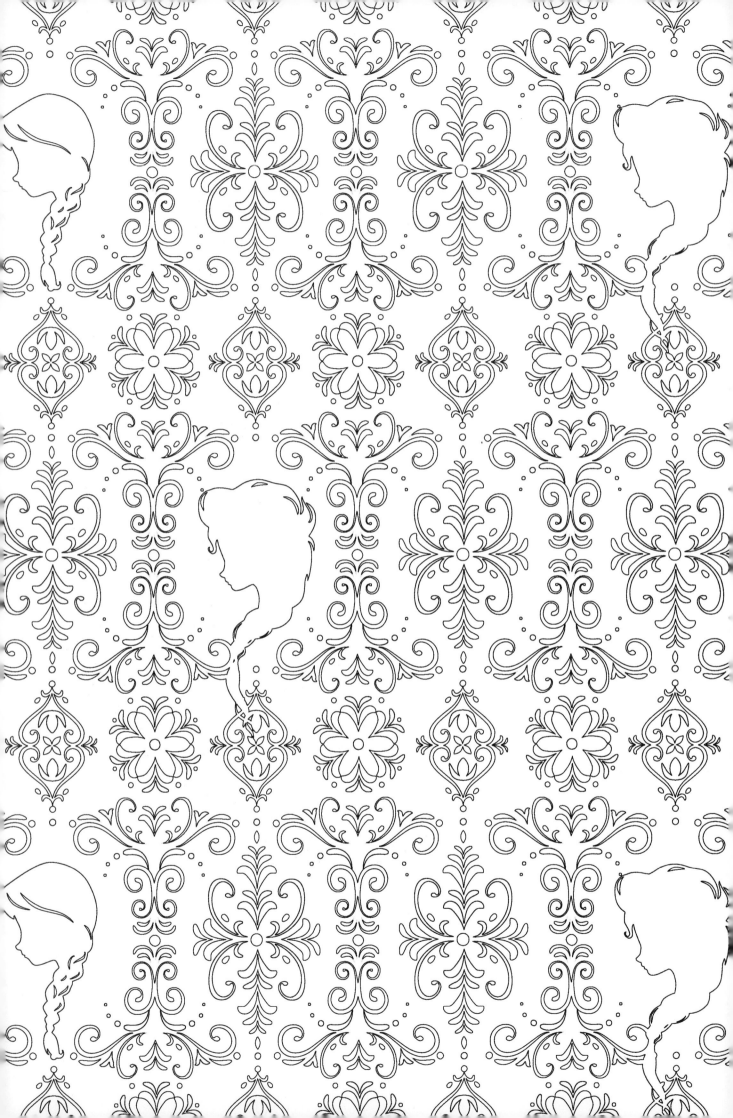

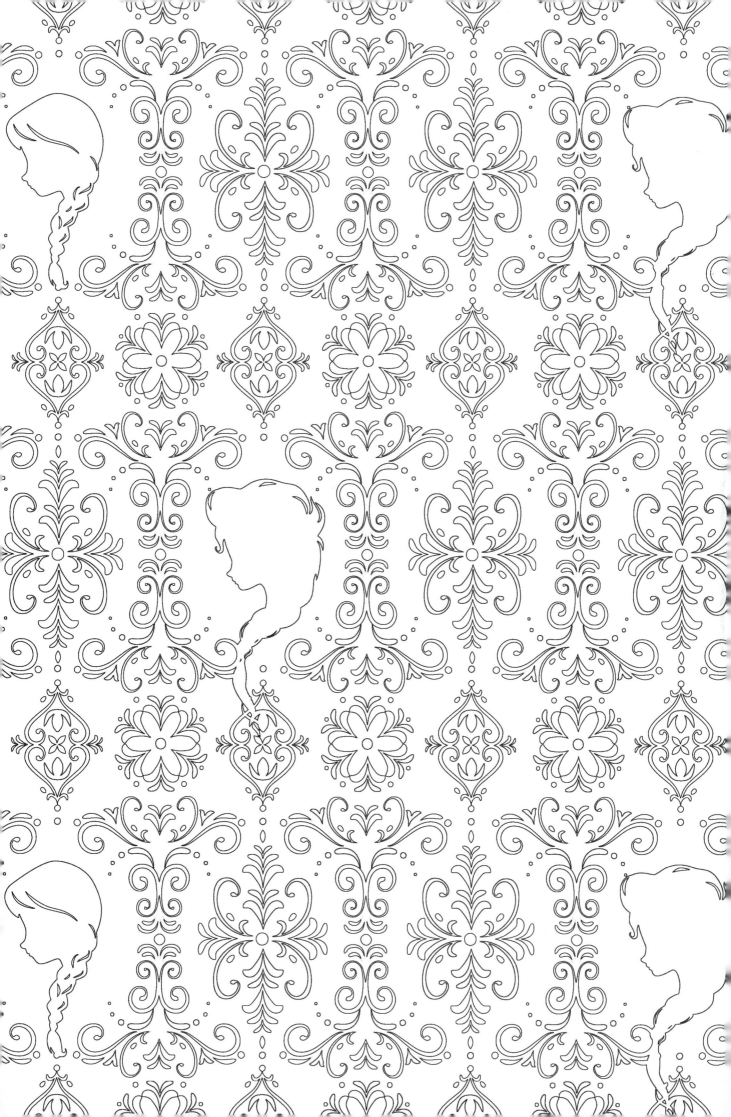

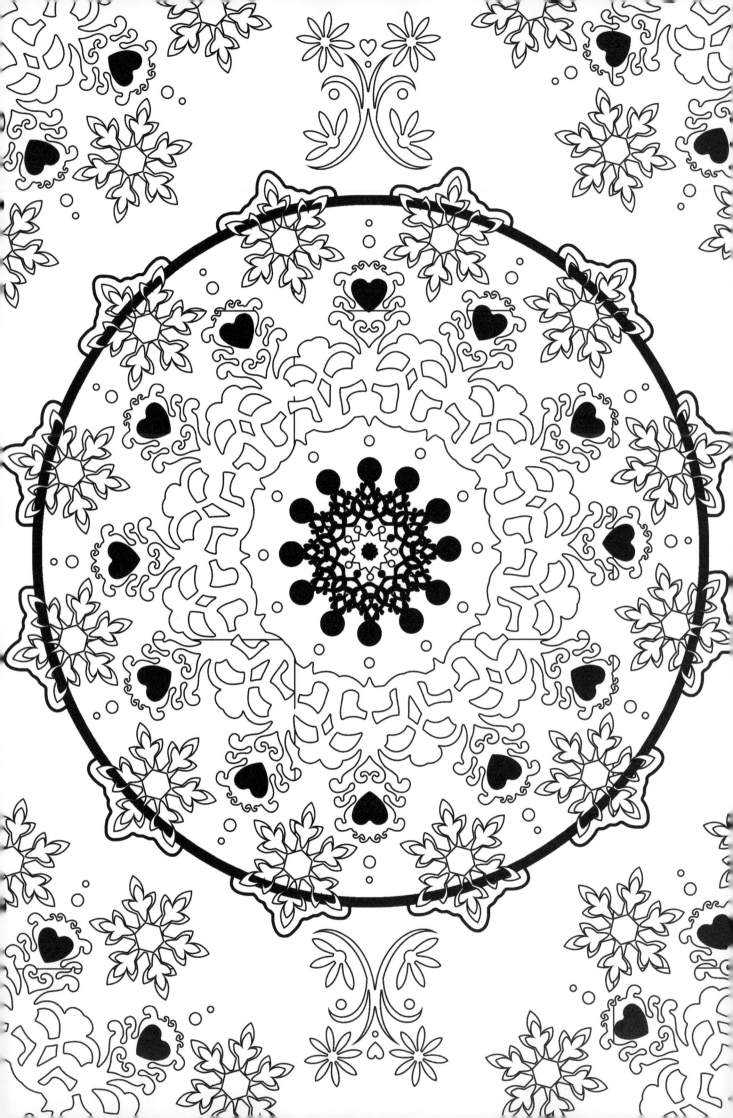

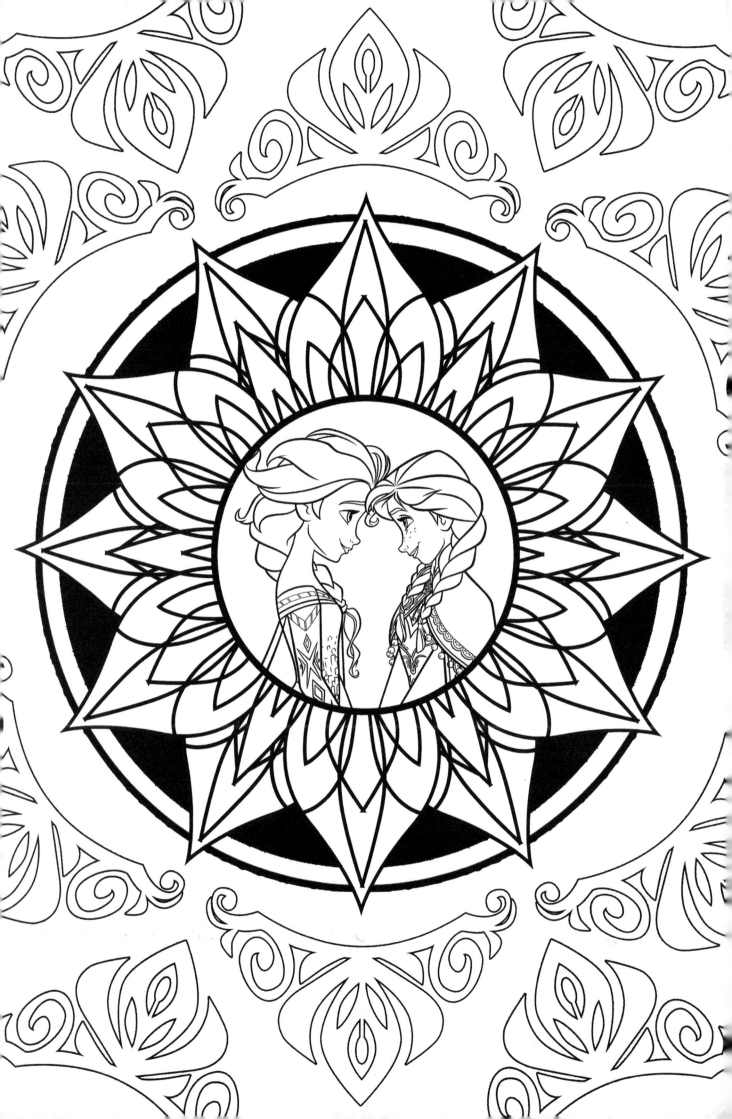

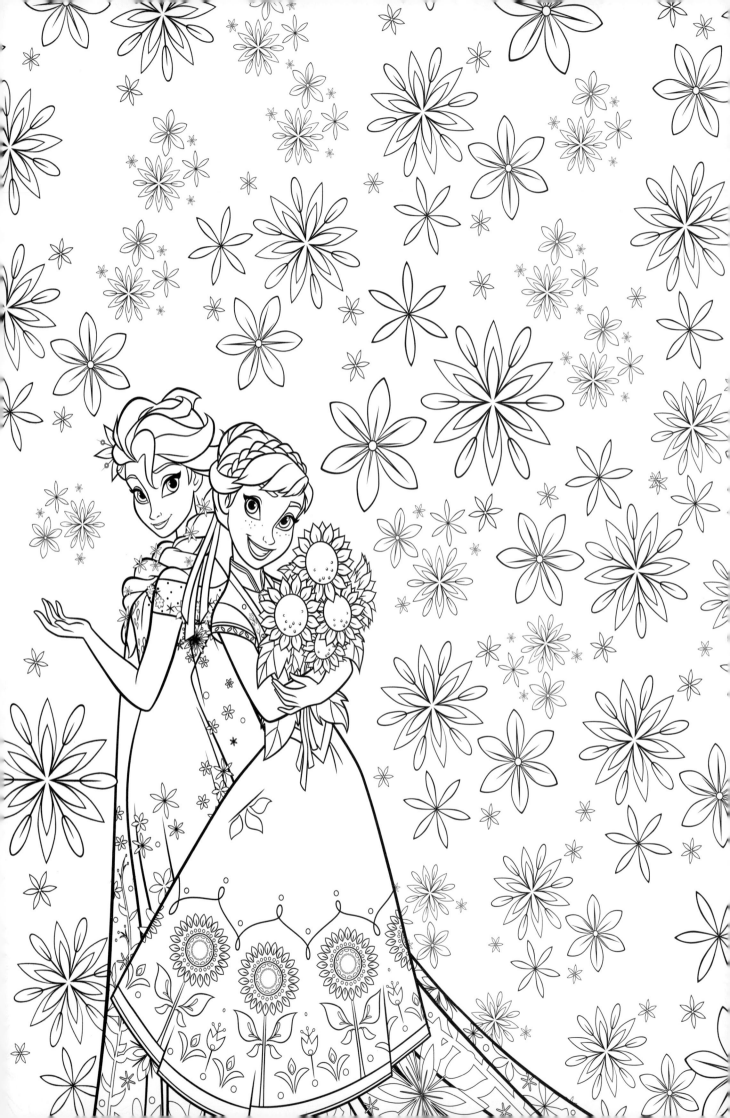

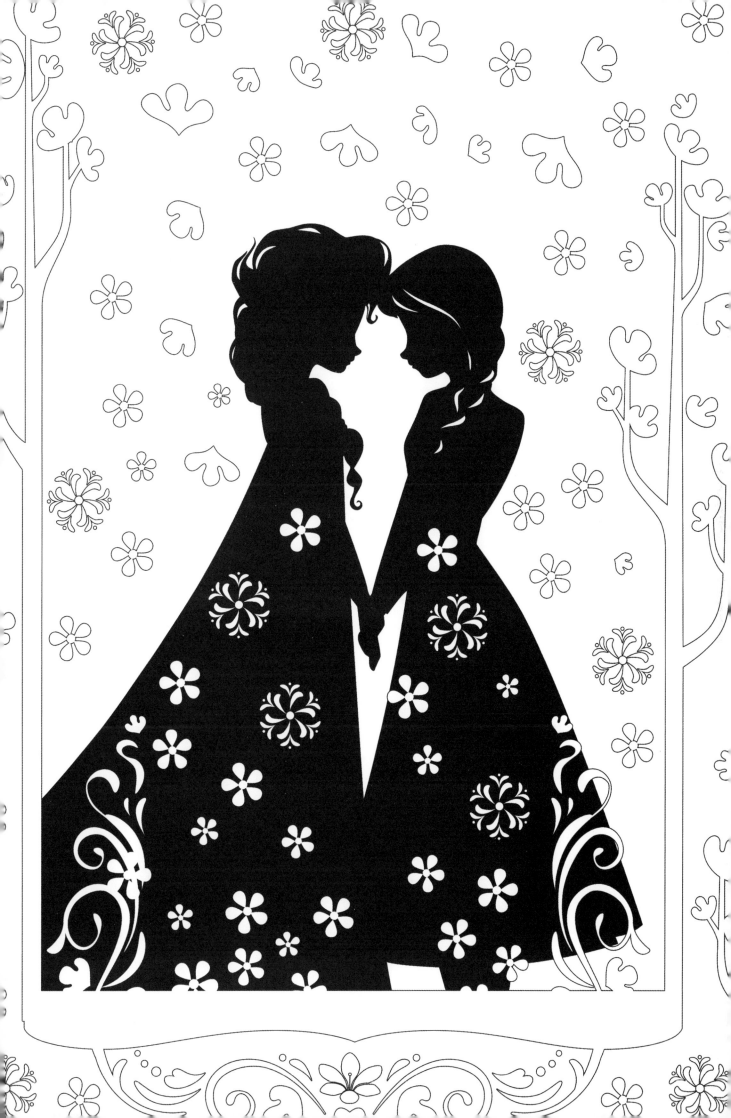

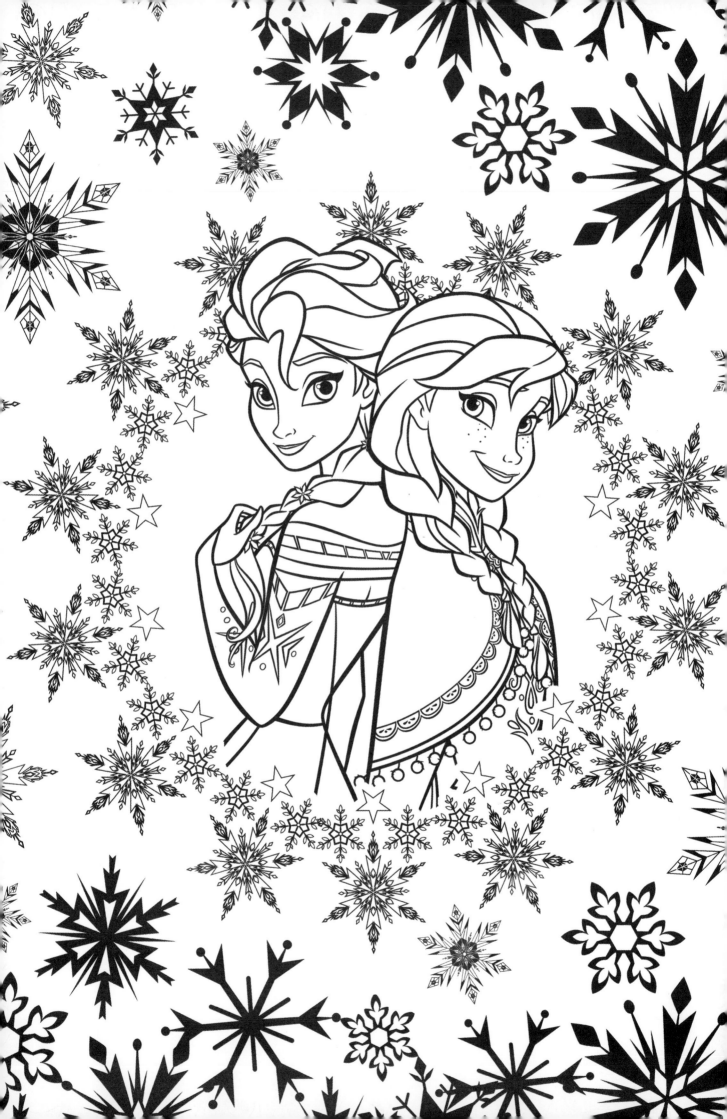

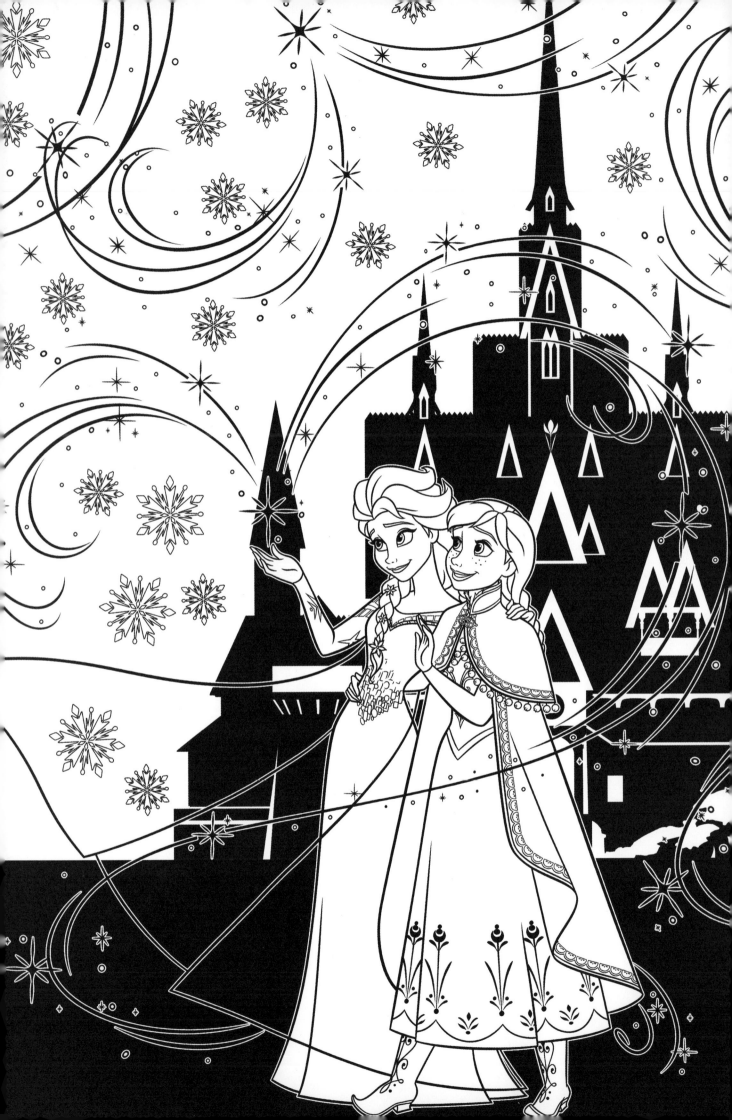

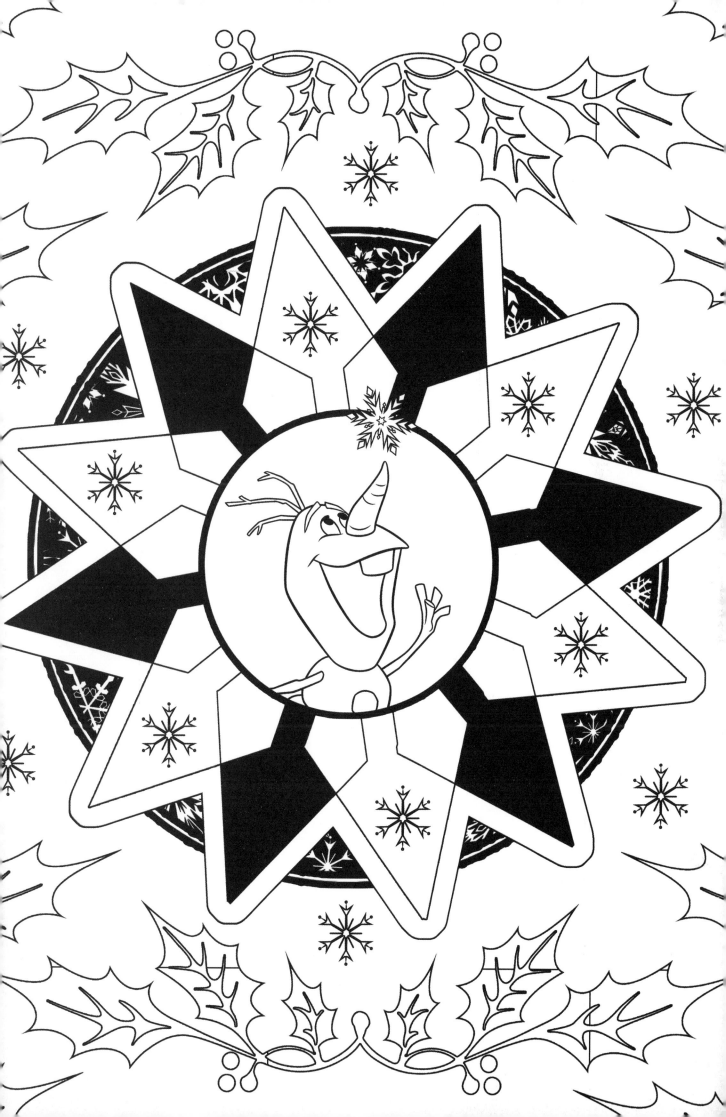

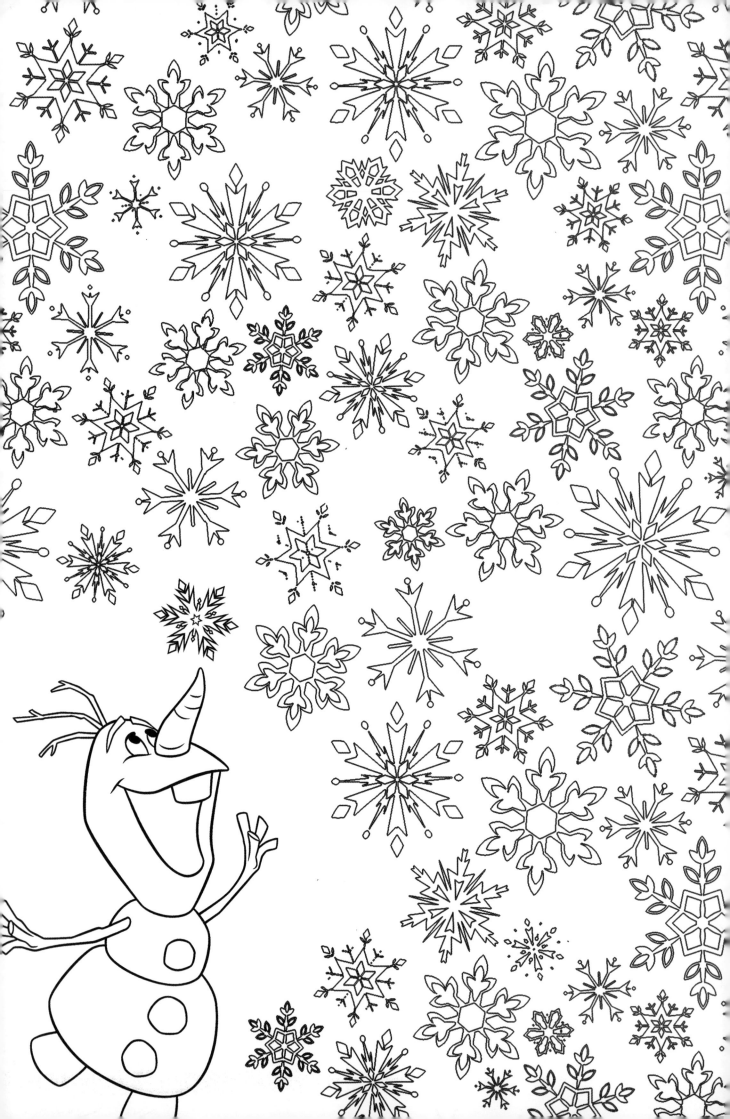

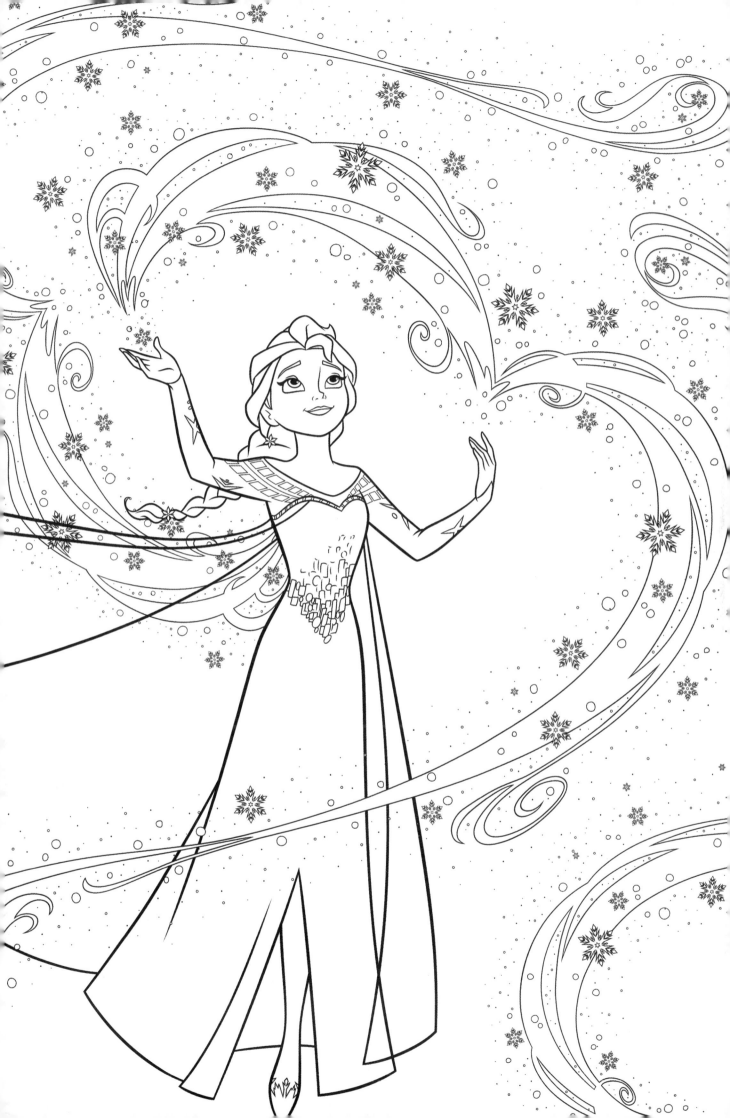

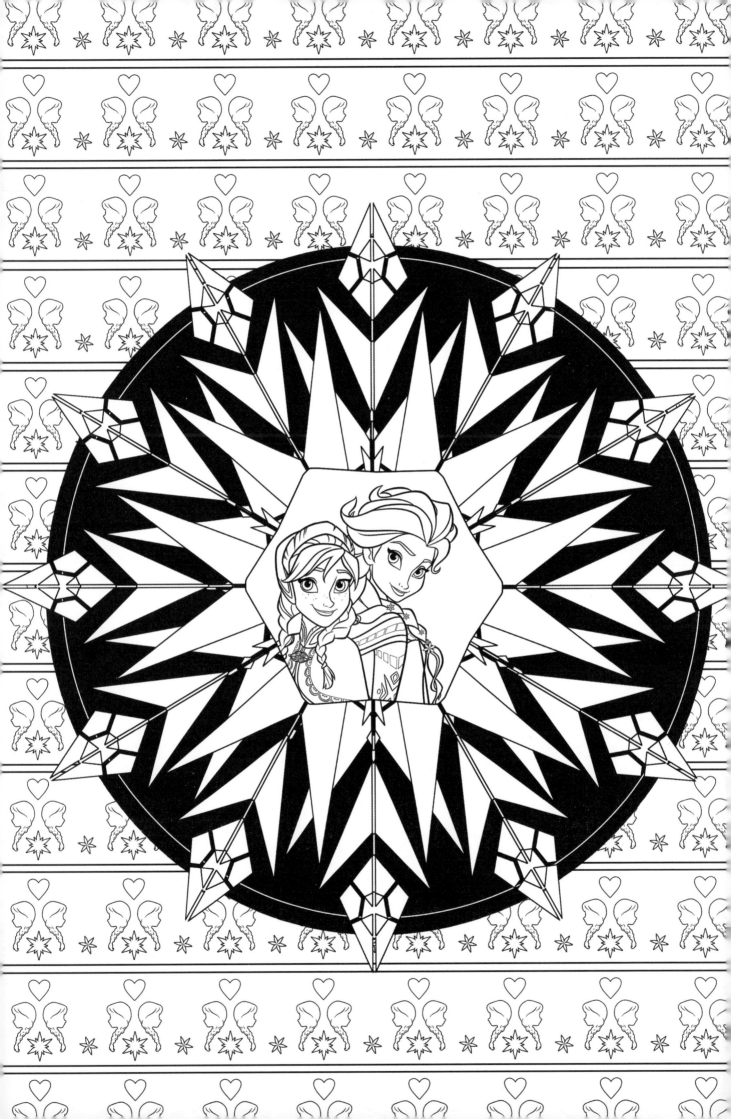